ARTHUR K. WHEELOCK, JR.

VERMEER

THE COMPLETE WORKS

HARRY N. ABRAMS, INC. PUBLISHERS

VERMEER

Vermeer is one of those rare artists whose works transcend the limits of time and place. His images, whether a young girl in an exotic turban, an intimate musical ensemble in a sunlit interior, or a view across a quiet street, have an immediacy that is as vivid today as it was to viewers in seventeenth-century Delft. Through his remarkable mastery of paint, we sense not only a variety of textures, from the broken surface of a bread basket to the translucency of glass, but also a radiant flow of light pervading his scenes. We also wonder at the beauty of his colors, which range from the lemon yellows of a woman's jacket to the vibrant reds of a fur hat. Finally, we encounter in his paintings people whose activities and preoccupations seem somehow familiar and related to our own lives.

The lasting appeal of Vermeer's images is not only the result of their seeming reality. They have a serenity and timelessness that imbue them with extraordinary dignity. Vermeer, moreover, infused his works with meanings that often are shrouded in mystery. He rarely explained

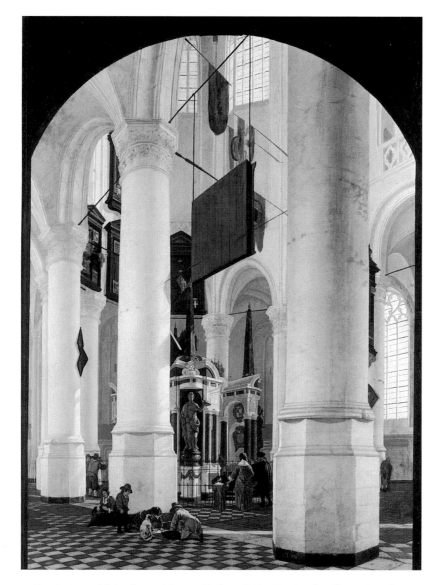

Fig. 1. Gerard Houckgeest, Nieuwe Kerk with the Tomb of William the Silent. *1650. Oil on panel, 49 ½ x 35" (125.7 x 89 cm). Hamburger Kunsthalle, Hamburg*

the context for his subjects or precisely delineated human emotions through gestures or facial expressions, preferring instead to allow each of us to contemplate the significance of the scene. In the process, we inevitably arrive at a greater understanding of our own feelings and the nature of our relationships to others.

Vermeer's life and artistic career are closely associated with Delft, a small city situated between The Hague and Rotterdam whose origins date back to the thirteenth century (Pl. 13). Although noted for its rough-hewn fortified walls and city gates, its picturesque canals and bridges, and an imposing town hall at one end of the bustling market square, the most important site in Delft was the magnificent tomb of William the Silent in the choir of the Nieuwe Kerk (Fig. 1). Designed by Hendrik de Keyser (1565–1621), the tomb attracted visitors from all over Europe. Not only was it the most magnificent monument in the Dutch Republic, it held enormous symbolic importance as the burial place of the Prince of Orange and his descendants.

The city's population, much of which depended on thriving Delftware factories, tapestry-weaving ateliers, and breweries for its livelihood, numbered about 20,000 when Vermeer was baptized in the Nieuwe Kerk on 31 October, 1632. Vermeer's father, Reynier Jansz., supported his family by running a small inn on the Voldersgracht, working as a silk weaver producing "caffa," a fine satin fabric, and acting as an art dealer. By 1641 he had become sufficiently prosperous to purchase the "Mechelen," an inn on the market square, from which he probably also dealt in paintings (Fig. 2). Vermeer almost certainly inherited this business after his father died in 1652.

Johannes, who, through his father's art dealings, must have grown up in the company of artisans, registered as a master painter in the St. Luke's Guild on 29 December, 1653. He had undoubtedly begun his apprenticeship in the late 1640s, since it took an aspiring artist about six years of training before becoming a master.

The identity of his master, or masters, is not known, although scholars have speculated that two Delft artists had significant influence on the young painter. The first is Leonard Bramer (1596–1674), one of the foremost Delft artists of the day. Documents prove that Bramer knew Vermeer: in April 1653 he served as a witness at the time of Vermeer's betrothal to Catharina Bolnes. Catharina had been raised as a Catholic, and it appears that her mother, Maria Thins, who had strong Jesuit leanings, insisted that Vermeer convert to Catholicism before the marriage could take place. Bramer, who was also a Catholic, witnessed a deposition by Vermeer's future mother-in-law stating that she would not stand in the way of the marriage. Apparently Vermeer did convert, and the marriage took place in December of that year, just before he enrolled as a master in the St. Luke's Guild.

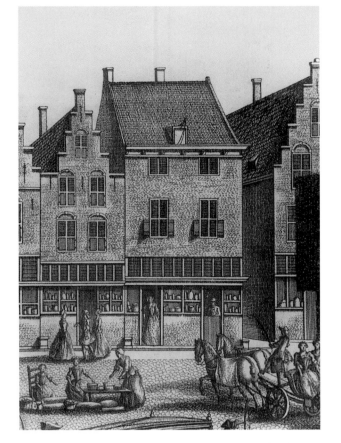

It is generally assumed that Vermeer studied in Delft, but, in fact, no documents mention Vermeer's presence in Delft between October 1632, when he was baptized, and April 1653, when he was engaged to Catharina Bolnes. Since his earliest works have little stylistic connection to paintings made in Delft during the late 1640s and early 1650s, it is possible that he trained elsewhere. Indeed, his early works have a certain resonance with the artistic traditions of Utrecht and Amsterdam. In Utrecht, where Vermeer's mother-in-law had family connections, artists such as Hendrick ter Brugghen (1588–1629) used blond tonalities, a broad manner of execution, and a focus on large-scale foreground figures (Fig. 5) that may have inspired Vermeer when he painted *Christ in the House of Mary and Martha,* c. 1655 (Pl. 2). On the other hand, Vermeer also had contacts in Amsterdam: his first documented painting, a now lost *Visit to the Tomb,* appears in the 1657 inventory of the Amsterdam collector and art dealer Johannes Renialme. Moreover, a number of thematic and compositional connections exist between Vermeer's early paintings and works by Amsterdam artists, particularly those by Rembrandt. For example, Vermeer adapted the pose of Bathsheba in Rembrandt's 1654 painting of this Old Testament heroine (see Fig. 14) for Diana in *Diana and Her Companions,* c. 1655–56 (Pl. 3).

Vermeer's earliest known painting, *Saint Praxedis* (Pl. 1), signed and dated 1655, is a free copy of a composition by the Florentine artist Felice Ficherelli (1605–c. 1669) (see Fig. 12), which also raises the possibility that Vermeer traveled to Italy as part of his artistic education. Although Vermeer may have known Ficherelli's painting through the Dutch art market, the tradition of making such a study trip was well established in the seventeenth century, particularly in Utrecht and Delft. Leonard Bramer, for example, spent many years in Italy. Whether or not Vermeer visited Italy, he had sufficient knowledge of Italian art to be identified later in his career as an expert in the field. A 1672 document describes how Vermeer and another Delft

The 1653 documents, however, hardly prove that Bramer was Vermeer's teacher, since they make no reference to Vermeer's artistic career. It may be that Bramer served as a witness because he was a family friend rather than the master of the younger artist. In fact, the active poses of the exotic figures in Bramer's small, dark paintings on copper and panel (Fig. 3) are stylistically very different from the restrained, large-scale forms in Vermeer's early biblical and mythological paintings, *Saint Praxedis* (Pl. 1), *Christ in the House of Mary and Martha* (Pl. 2), and *Diana and Her Companions* (Pl. 3).

The second artist postulated as Vermeer's teacher is Carel Fabritius (1622–1654). This dynamic young painter, who had been trained in Amsterdam by Rembrandt van Rijn (1606–1669), came to Delft in 1650. He quickly gained great renown for his portraits and his innovative use of perspective before his untimely death when a powderhouse exploded in Delft in 1654. Evidence of Fabritius's evocative use of optics and perspective still exists in his small *View of Delft with a Musical Instrument Dealer,* 1652 (Fig. 4). The artist painted this melancholic image, with its view of the Nieuwe Kerk, shortly after the crypt beneath the tomb of William the Silent had been opened to receive the body of William II, the Prince of Orange, who died unexpectedly in December 1650.

Although Vermeer's history paintings are infused with the pensive, melancholic mood of Fabritius's genre scenes, he did not similarly exploit perspectival and optical effects in these early works. Thus, as with Bramer, stylistic evidence does not indicate that Vermeer took Fabritius's example as his artistic point of departure.

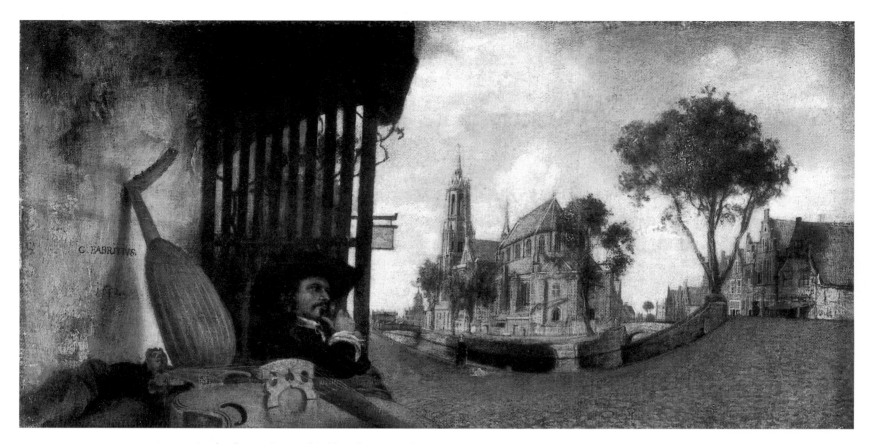

Fig. 4. Carel Fabritius, View of Delft with a Musical Instrument Dealer. 1652. Oil on canvas, laid down on panel, 6 ⅛ x 12 ⅞" (15.5 x 32.7 cm). Reproduced by Courtesy of the Trustees, National Gallery, London

artist were called upon to authenticate Italian paintings in The Hague. Vermeer's decision to paint the overtly Catholic subject of *Saint Praxedis* in 1655 probably reflects the powerful influence of his mother-in-law. Indeed, Vermeer and Catharina Bolnes seem to have enjoyed a close relationship with Maria Thins. Not only did she lend the young couple financial support shortly after their marriage, but they soon moved to her home in the so-called "Papists' Corner" of Delft, adjacent to the Jesuit church on the Oude Langendijck, one of the two hidden churches where Catholics could worship. Vermeer and Catharina Bolnes even named their first daughter Maria in her honor, and a son Ignatius, after the patron saint of the Jesuit order.

Aside from the close familial bonds that Maria Thins's personality engendered and the importance of her Catholic beliefs, she must have valued the role of artists and paintings in society. Not only was she distantly related to the Utrecht painter Abraham Bloemaert (1564–1651), she had also inherited a small group of paintings from the Utrecht school, which she made available to Vermeer. At least two of the works from her collection appear in Vermeer's paintings, *The Procuress* (Fig. 6) by Dirck van Baburen (1590/91–1624), which Vermeer included in both *The Concert* (Pl. 22) and *A Lady Seated at the Virginal* (Pl. 35), and a *Roman Charity*, which can be seen in the *Music Lesson* (Pl. 14). A number of other paintings and objects appearing in Vermeer's interiors came from his own collection, or at least from his stock, since he, like his father, was an art dealer. For example, the large *Crucifixion* by Jacob Jordaens (1593–1678), the ebony crucifix, and the gilt leather panel appearing in Vermeer's *Allegory of Faith* (Pl. 33) are all listed in the inventory of his possessions made after his death.

Whether Vermeer's initial impulse to be a history painter was stimulated by his artistic training, his conversion to Catholicism, or the

hope that he would realize prestigious princely or civic commissions, he abruptly and dramatically changed his subject matter and style of painting a few years after becoming a master in the guild. Although the reasons he began to focus on scenes such as *A Woman Asleep* (Pl. 5), *Girl Reading a Letter at an Open Window* (Pl. 6), or *The Little Street* (Pl. 7) are not known, it may be that the patronage he expected as a history painter was not forthcoming. Perhaps, as well, he came to realize that while he was a talented painter of biblical and mythological scenes, his true artistic genius lay in his ability to convey a comparable sense of dignity and purpose in images drawn from daily life.

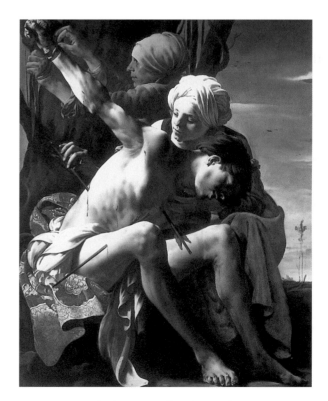

Fig. 5. Hendrick ter Brugghen, Saint Sebastian. 1625. Oil on canvas, 58 ⅞ x 47 ¼" (149.5 x 120 cm). Allen Memorial Art Museum, Oberlin College, Ohio, R.T. Miller, Jr., Fund, 1953

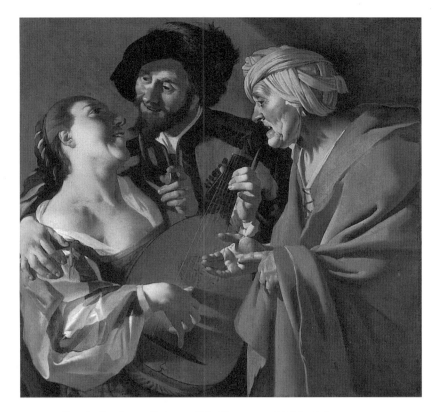

Fig. 6. Dirck van Baburen, The Procuress. 1622. Oil on canvas, 40 x 42 ³/₈″ (101.5 x 107.6 cm). M. Theresa B. Hopkins Fund, Courtesy, Museum of Fine Arts, Boston

Although the path Vermeer took in defining his artistic personality is understood in only the broadest of terms, the types of scenes he represented in the late 1650s indicate that he was aware of his contemporaries' work, and was adept at emulating and improving upon their images. For example, the paintings of Gerard ter Borch (1617–1681), a genre painter who lived in Deventer, apparently inspired Vermeer. Despite working in different cities, the two artists knew each other, for they co-signed a document in Delft on 22 April, 1653, just two days after Vermeer's betrothal to Catharina Bolnes. A few years later, the older master's sensitive depictions of women engaged in quiet activities in the privacy of their homes (Fig. 7) apparently served as a model for Vermeer when he painted *Girl Reading a Letter at an Open Window*, c. 1657 (Pl. 6).

Another artist who seems to have been important for Vermeer at this crucial stage of his career was Nicolaes Maes (1634–1693), who had studied with Rembrandt in Amsterdam in the early 1650s. Around 1655 Maes returned to his native Dordrecht, where he developed a fascinating style of genre painting that Vermeer certainly knew when conceiving his *A Woman Asleep* (Pl. 5). Maes delighted in creating complex interior spaces, with foreground and background rooms that served as settings for separate yet related episodes in his scenes (Fig. 8). As in this instance, where the mistress of the household explicitly points out the slothful behavior of a servant who has neglected her duties, many of Maes's paintings are moralizing in character.

Vermeer also sought to convey meaning in his paintings, but his approach differed fundamentally from that taken by artists like Maes. The figures in his paintings take on a timeless presence that imparts to them an extraordinary dignity and moral gravity comparable to that seen in history painting. He achieved this effect by minimizing the narrative rather than emphasizing it as did Maes, through the use of

subsidiary figures and momentary gestures. Vermeer also understood the important psychological impact of perspective, light, and color for creating mood.

The great mystery, of course, is how Vermeer arrived at this approach. No other Dutch genre painter sought to create such evocative and timeless images in this way, not Fabritius, not ter Borch, not Maes, not even Pieter de Hooch (1629–1684), the Delft artist who comes closest to Vermeer's manner of painting. De Hooch, who painted low-life genre and guardroom scenes as an artist in Rotterdam, moved to Delft in 1654, soon after Vermeer registered as a master in the Delft St. Luke's Guild. His style quickly evolved, and he began to paint light-filled interiors (see Fig. 16) and courtyard scenes (Fig. 9) with soldiers mingling with middle-class citizens as they enjoy a leisurely afternoon of eating, drinking, smoking, or playing cards. One senses in his work, and in Vermeer's paintings from the late 1650s, among them *Officer and Laughing Girl* (Pl. 8) and *The Little Street* (Pl. 7), the quiet comfort of a people at peace with themselves and the world, with no reference made to such tragedies as the devastation of the city caused by the powderhouse explosion in 1654 (Fig. 10).

No documents link Vermeer with de Hooch. Nevertheless, similarities in their choice of subject matter, interest in naturalistic light effects, and use of perspective, both to define space and to reinforce the painting's thematic emphasis, indicate that they knew and responded to each other's work. Connections between their paintings even exist after de Hooch moved to Amsterdam in the early 1660s. Surprisingly, since Vermeer seems to us today the greater artist, it is probable that de Hooch initiated most of the stylistic and thematic characteristics that their paintings share.

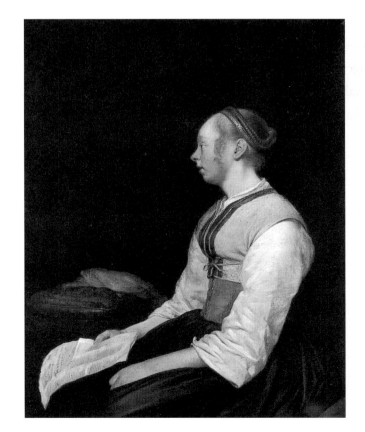

Fig. 7. Gerard ter Borch, Peasant Girl Reflecting on a Letter. c. 1650. Oil on panel, 11 x 9 ¹/₁₆″ (28 x 23 cm). Rijksmuseum, Amsterdam

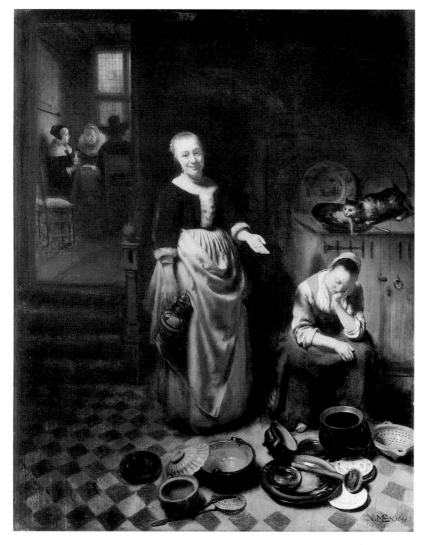

Fig. 8. Nicolaes Maes, The Idle Servant. 1655. Oil on canvas, 27 1/2 x 21"
(70 x 53.3 cm). Reproduced by courtesy of the Trustees, National Gallery, London

mixed with his paint to emulate the broken surface of red-tile roofs in the *View of Delft* (Pl. 13).

As an artist intent upon discovering the secrets of the visible world and finding ways to convey them in his works, it is not surprising that Vermeer also exploited effects seen in a camera obscura. This fascinating optical device operates much like a box camera. It creates an image by allowing rays to enter through a small opening, which can be fitted with a focusing tube and lens. The rays are then projected onto a wall or, in the case of a portable camera obscura, onto a ground glass opposite the aperture (Fig. 11). This device opened a new range of expressive possibilities that Vermeer often used to give his images a heightened sense of immediacy. He discovered, for example, that in a camera obscura unfocused accents of light reflecting off shiny surfaces created diffused highlights that he could translate into paint. He then used these effects in a variety of ways, to suggest the flickering reflections of water on the sides of a boat in *View of Delft* (Pl. 13), the freshness of newly baked bread in *The Milkmaid* (Pl. 9), or unfocused foregrounds in small, intimate paintings like *The Lacemaker* (Pl. 29) or *Girl with the Red Hat* (Pl. 23).

Vermeer must have painted slowly, since only about thirty-five of his works are now known. It seems unlikely that many more ever existed. Despite his small output, he was a respected artist in Delft, and was elected headman of the Guild of Saint Luke in both 1662 and 1670. However, while the few documents mentioning him during his lifetime are complimentary, they do not indicate that he was recognized as an artistic genius in his own day.

Vermeer employed many devices beyond his expressive use of light, color, and perspective to extend the meanings of his scenes. In a number of works he included objects imbued with symbolic associations. Paintings within his interiors frequently provide commentaries on the scene transpiring before them, as, for example, the *Last Judgment* hanging within *Woman Holding a Balance* (Pl. 16), or the painting of Cupid holding aloft a card in *A Lady Standing at the Virginal* (Pl. 34), a reference to an image in Otto van Veen's popular emblem book, *Amorum Emblemata*, 1608, that admonishes the reader to have but one lover (see Fig. 22). Vermeer, in fact, frequently painted figures playing music, exploring in these works themes of love and harmony so often associated with musical instruments. Similarly, he used maps, letters, pearls, and water pitchers as focal points within his compositions because their symbolic associations were fundamental to the meanings he wished to infuse into them.

Vermeer's paintings from the late 1650s and 1660s are characterized by a number of stylistic elements, including a seemingly naturalistic flow of light; subtly nuanced colors; carefully conceived spatial arrangements achieved through a sophisticated awareness of linear perspective; and, above all, an understanding of the expressive qualities of paint. He mastered the use of glazes, exploiting their translucency to give depth and resonance to his colors. He perceived the forceful power of thick impastos to create textural effects and compositional emphasis. He also used unconventional techniques, for example, gold to accent a brass nail on a chair in *A Woman Asleep* (Pl. 5), and sand

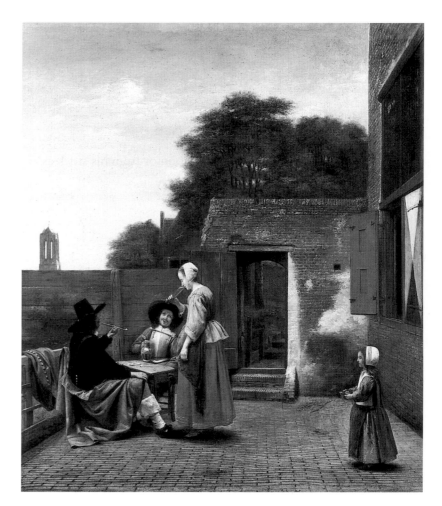

Fig. 9. Pieter de Hooch, A Dutch Courtyard. c. 1658–60. Oil on canvas,
26 3/4 x 23" (68 x 58.4 cm). Andrew W. Mellon Collection,
© 1997 Board of Trustees, National Gallery of Art, Washington, D.C.

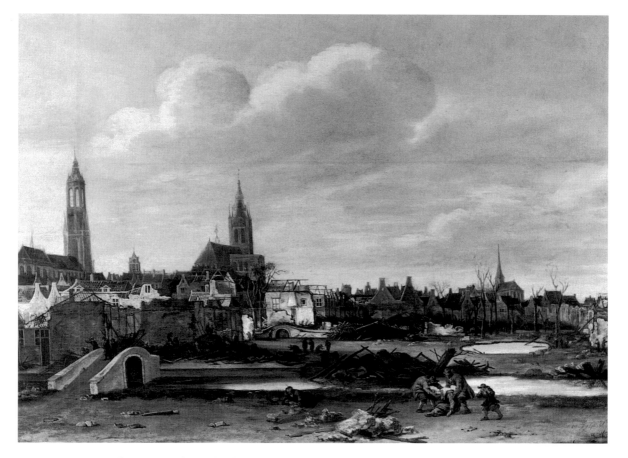

Fig. 10. Daniel Vosmaer, Aftermath of the Explosion of the Powder Magazine at Delft on October 12, 1654. *Oil on panel, 28 ³⁄₈ x 38 ¹⁄₈" (72 x 97 cm). Stedelijk Museum Het Prinsenhof, Delft*

Vermeer seems to have lived a comfortable life until 1672, when the art market collapsed after France invaded the Netherlands. His financial fortunes quickly deteriorated, and, when he died in 1675, he left his wife and eleven children with enormous debts. To help resolve various legal conflicts, including the rights to ownership of *The Art of Painting* (Pl. 24), which Maria Thins sought to preserve in the family, the city fathers of Delft appointed the famed Delft microscopist Anthony van Leeuwenhoek (1632–1723) executor of Vermeer's estate. Finally, on 15 March, 1677, van Leeuwenhoek arranged for a sale of paintings from Vermeer's estate, including *The Art of Painting*, to help satisfy the demands of Vermeer's creditors. Although other of Vermeer's paintings were probably included in the auction, undoubtedly most were works from his own collection or from his stock as an art dealer.

Vermeer seems to have painted most of his works for a few Delft collectors, among them the patrician Pieter Claesz. van Ruijven (1624–1674). Partially through inheritance, twenty-one of Vermeer's paintings, including the *View of Delft* (Pl. 13), eventually became the property of the Delft printer Jacob Dissius (1653–1695). After Dissius's death his entire collection was sold in Amsterdam in 1696. While Vermeer's works were admired by a small group of discerning collectors in the eighteenth and nineteenth centuries, the enormous enthusiasm for his extraordinary achievement only developed in the late nineteenth century. The man responsible was Étienne-Joseph-Théophile Thoré (1807–1869). Thoré, who wrote under the pseudonym of William Bürger, traveled across Europe to try to find all the paintings created by this long-neglected genius. His enthusiastic accounts brought Vermeer's name for the first time to a wide public, and helped establish the artist's international fame.

SUGGESTIONS FOR FURTHER READING:

Blankert, Albert (with contributions by Rob Ruurs and Willem van de Watering). *Johannes Vermeer van Delft 1632–1675.* Oxford and New York, 1978.

Montias, John Michael. *Vermeer and His Milieu: A Web of Social History.* Princeton, 1989.

Wheelock, Arthur K., Jr. *Vermeer and the Art of Painting.* New Haven and London, 1995.

Wheelock, Arthur K., Jr., ed. *Johannes Vermeer.* (Exhibition catalogue, National Gallery of Art and Royal Cabinet of Paintings, Mauritshuis.) Washington, D.C., 1995.

Fig. 11. Stefano della Bella (?), Camera Obscura. *From a 17th-century manuscript of military fortifications, drawing, pen and brown ink, 4 ¹⁄₄ x 6 ¹⁄₈" (10.8 x 15.5 cm). Rosenwald Collection, Library of Congress, Washington, D.C.*

Plate 1

SAINT PRAXEDIS

1655. Oil on canvas, 40 x 32 ½″ (101.6 x 82.6 cm).
Private collection

Vermeer based the composition of this recently discovered painting, with its striking subject mattter, bold composition, and intense colors, on a work by the seventeenth-century Florentine artist Felice Ficherelli (Fig. 12). His decision to depict this second-century Roman Christian, who was revered for caring for the bodies of martyrs, provides a number of fascinating insights into an early stage of Vermeer's career. It demonstrates that his conversion to Catholicism in 1654 was an important commitment of faith. Indeed, Vermeer even added a crucifix to Ficherelli's composition to suggest symbolically that the blood of the martyrs is being mixed with the blood of Christ.

Vermeer was adept at emulating other artists' techniques and styles, a characteristic that may account for the range of styles evident in his early biblical and mythological paintings. Here, however, he has given the saint a more physical presence than that seen in the Italian prototype. His colors are also more vivid and his mixtures of paint more complex. For example, to suggest the luminous sheen of Saint Praxedis's raspberry-colored dress he has subtly applied a thin red glaze over a white underpaint. Although the painting's subject differs from that of his later genre scenes, Vermeer adapted the saint's quiet, reverential mood in a number of works, including *A Woman Asleep* (Pl. 5) and *Woman Holding a Balance* (Pl. 16).

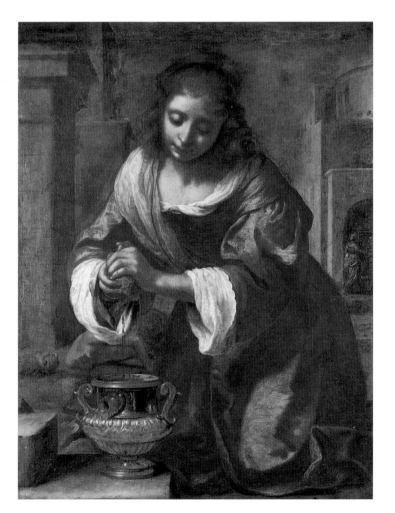

Fig. 12. Felice Ficherelli, Saint Praxedis.
c. 1645. Oil on canvas, 41 x 31 ⅝″ (104 x 80.5 cm).
Collection Fergnani, Ferrara

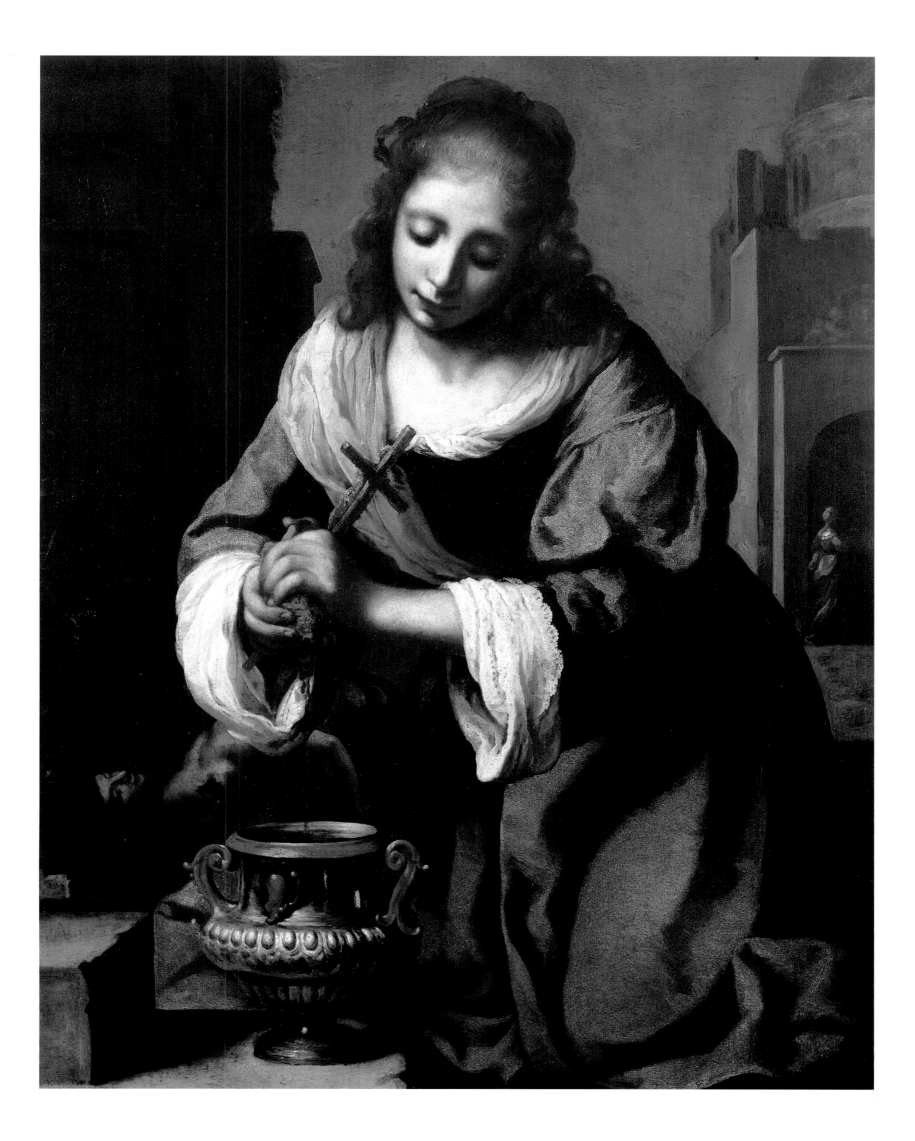

Plate 2

CHRIST IN THE HOUSE OF MARY AND MARTHA

c. 1655. Oil on canvas, 63 x 55 ⅞" (160 x 142 cm).
National Galleries of Scotland, Edinburgh

This large and imposing painting depicts the story from the Gospel of Saint Luke 10: 38–42, where Christ, traveling with his disciples, is welcomed into the home of Mary and her sister Martha. The Bible describes how Martha then busied herself preparing the meal, while Mary sat at Christ's feet listening to his words. Martha then protested, and asked Christ to tell Mary to help. He responded that "Mary has chosen the better part, which shall not be taken from her." Mary came to symbolize the *vita contemplativa* while Martha represented the *vita activa,* a contrast that was central to the disputes between Catholics and Protestants about the proper path to salvation.

Most artists, including Erasmus Quellinus, whose work Vermeer may have known, depicted this scenario by separating Martha from the tightly knit group of Mary and Christ (Fig. 13). Vermeer, perhaps inspired by religious paintings made in Utrecht by Hendrick ter Brugghen (see Fig. 5), drew the group together, emphasizing the physical and psychological interactions of the figures. Vermeer's interpretation of the scene is significant, since Catholics believed that the joining of faith and good works, such as those performed by Martha, was a means toward salvation. He also depicted Martha offering Christ a basket of bread, which is theologically important because of bread's Eucharistic connotations.

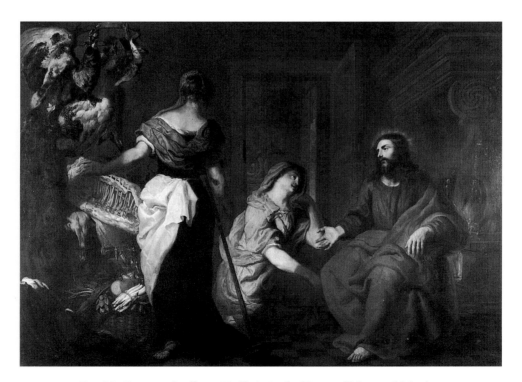

Fig. 13. Erasmus Quellinus II, Christ in the House of Mary and Martha.
c. 1645. Oil on canvas, 67 ¾ x 95 ¾" (172 x 243 cm).
Musée des Beaux-Arts, Valenciennes

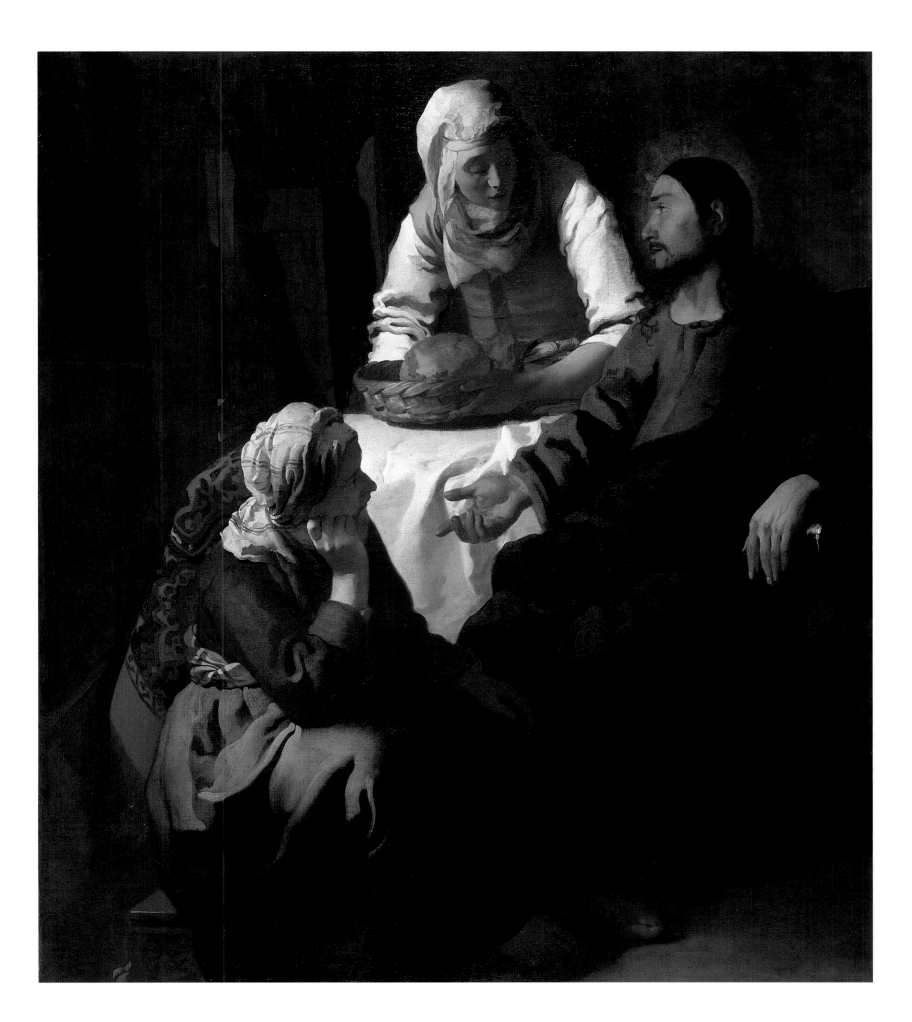

Plate 3

DIANA AND HER COMPANIONS

c. 1655–1656. Oil on canvas, 38 ¾ x 41 ⅜" (98.5 x 105 cm).
Mauritshuis, The Hague

In this evocative mythological painting, Diana sits with her companions near the edge of a dark and impenetrable forest. As evening falls, she gazes unseeingly into the distance while one of her companions kneels before her, attending to her feet. The quiet and somber mood is unusual for depictions of this fleet-footed goddess, who, when not shown hunting with bow and arrow, is often bathing with her nymphs, splashing water upon Actaeon to transform him into a deer, or confronting the pregnant Callisto.

Vermeer has given Diana only one attribute, the crescent moon, that identifies her as goddess of the night. This role, symbolically associated with death, is central to Vermeer's artistic intent. Other pictorial elements reinforcing this theme are the thistle and geranium, symbols of earthly sorrow, and foot-washing, which in Christian traditions alludes to purification, humility, and approaching death.

Probably because of this thematic connection Vermeer adapted the pose of Diana from Rembrandt's *Bathsheba*, 1654 (Fig. 14), where the Old Testament heroine sits contemplating the weighty implications of David's letter. Vermeer may have conceived his painting in response to a personal loss, perhaps the untimely death of Carel Fabritius in the powderhouse explosion of 1654.

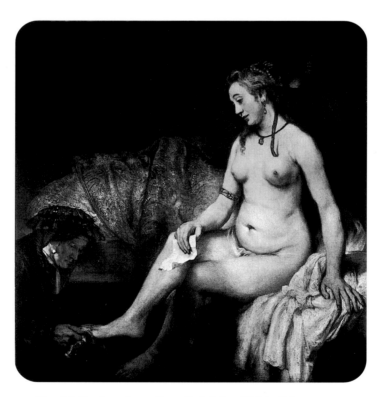

Fig. 14. Rembrandt van Rijn, Bathsheba. 1654. Oil on canvas,
55 ⅞ x 55 ⅞" (142 x 142 cm). Musée du Louvre, Paris

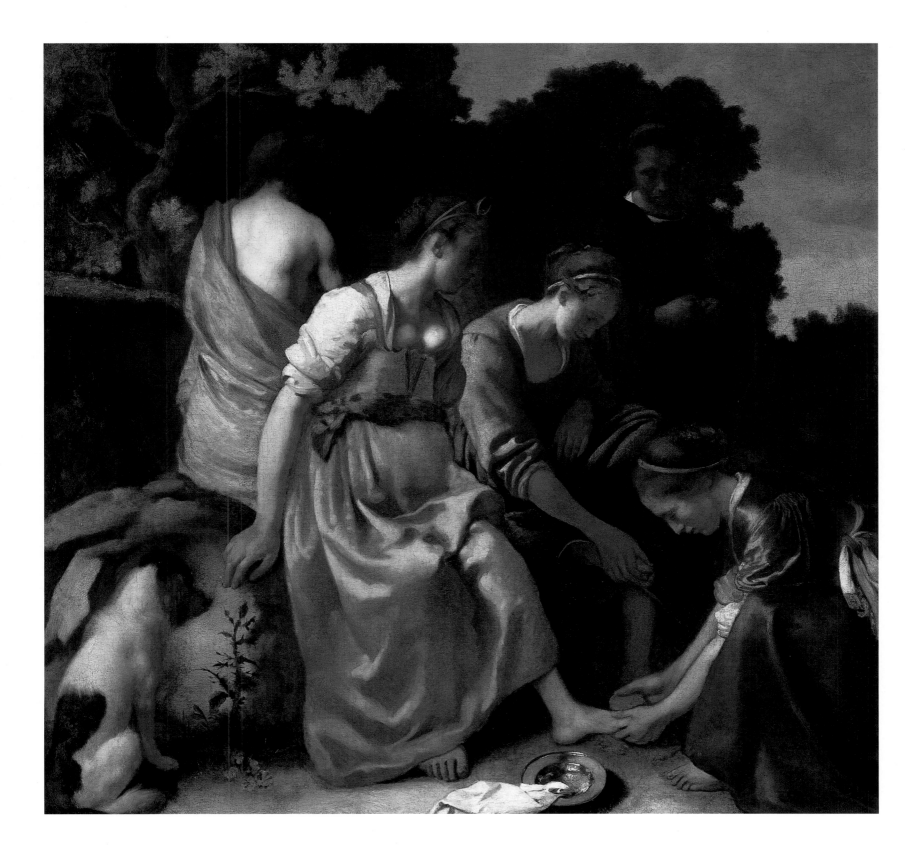

Plate 4

THE PROCURESS

1656. Oil on canvas, 56 ⅛ x 51 ⅛" (143 x 130 cm).
Staatliche Kunstammlungen, Gemäldegalerie, Dresden

Few of Vermeer's paintings are as provocative as this fascinating
scene of mercenary love, which, in its subject, as well as in its
momentary gestures and expressions, seems to differ from his earli-
er biblical and mythological scenes. Here, behind a balustrade cov-
ered by a richly decorated rug, a procuress looks approvingly at a
soldier, who offers a young woman a coin while fondling her breast.
Holding a glass of wine in one hand, she willingly accepts his
proposition with her other.

Vermeer was apparently inspired to paint this subject by Dirck
van Baburen's *The Procuress* (see Fig. 6), a painting that Maria
Thins owned and that Vermeer depicted in two of his works (see
Pls. 22 and 35). Nevertheless, Vermeer's painting may have biblical
allusions. On the left, an elegant dandy, dressed in a beret and a
fashionable slit-sleeve jerkin, smiles out at the viewer as he holds
aloft a glass and grasps a musical instrument. This dimly lit figure
is probably a self-portrait, with Vermeer assuming the guise of the
Prodigal Son, a role many seventeenth-century artists, including
Rembrandt, played in depictions of merry company scenes.

This painting is the first instance in which Vermeer strove for a
sense of realism through his painting techniques. For example, he
used thick impastos to convey the rough texture and three-dimen-
sional character of the ceramic wine pitcher.

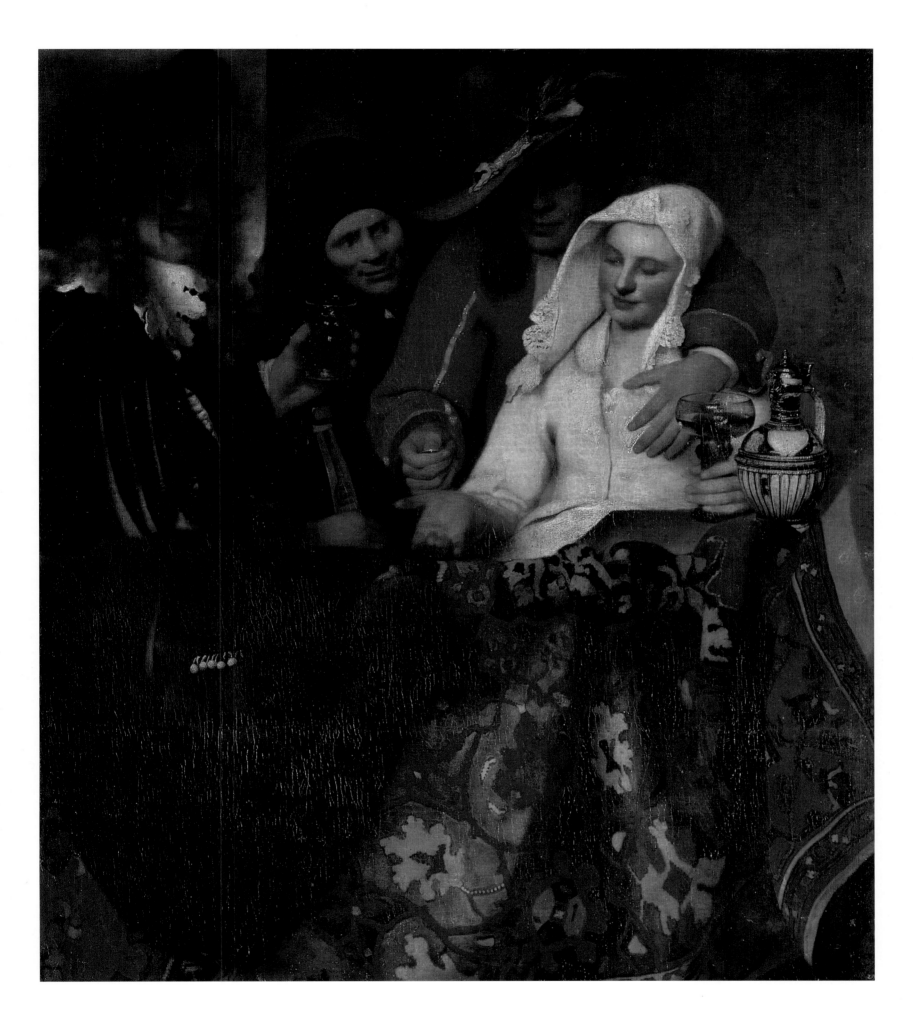

Plate 5

A WOMAN ASLEEP

c. 1657. Oil on canvas, 34 ½ x 30 ⅛" (87.6 x 76.5 cm).
The Metropolitan Museum of Art, New York. Bequest of
Benjamin Altman, 1913

This painting, which is probably Vermeer's earliest genre scene, places a sleeping or inebriated woman in a restricted space between a heavily-laden table and a half-opened door leading to a distant light-filled room. The earth tones and deep reds of the palette, as well as the unusual spatial organization, are reminiscent of paintings by Nicolaes Maes, who influenced Vermeer at this stage of his career (see Fig. 8). However, unlike Maes, Vermeer neither explains the narrative nor provides a moralizing commentary about the woman's state of being.

Such, however, was not always the case. X-radiographs demonstrate that Vermeer initially included a dog in the doorway and a gentleman in the back room (Fig. 15), compositional elements that were thematically related to the woman's melancholic, or slothful, appearance. The artist, however, painted out these figures, leaving the viewer alone with the woman in a darkened and claustrophobic chamber, without any explanation for her weighty, and even despondent, mood. The elimination of these elements provides an important insight into Vermeer's thought process. They reveal that he sought a poetic image rather than explicit narrative, where the viewer, guided by the figure's melancholic pose, the evocative light effects, and the unusual spatial arrangement, is allowed great latitude in interpreting the scene.

Fig. 15. X-radiograph of Johannes Vermeer, A Woman Asleep. *c. 1657. Oil on canvas, 34 ½ x 30 ⅛" (87.6 x 76.5 cm). The Metropolitan Museum of Art, New York. Bequest of Benjamin Altman, 1913. Sherman Fairchild Paintings Conservation Department*

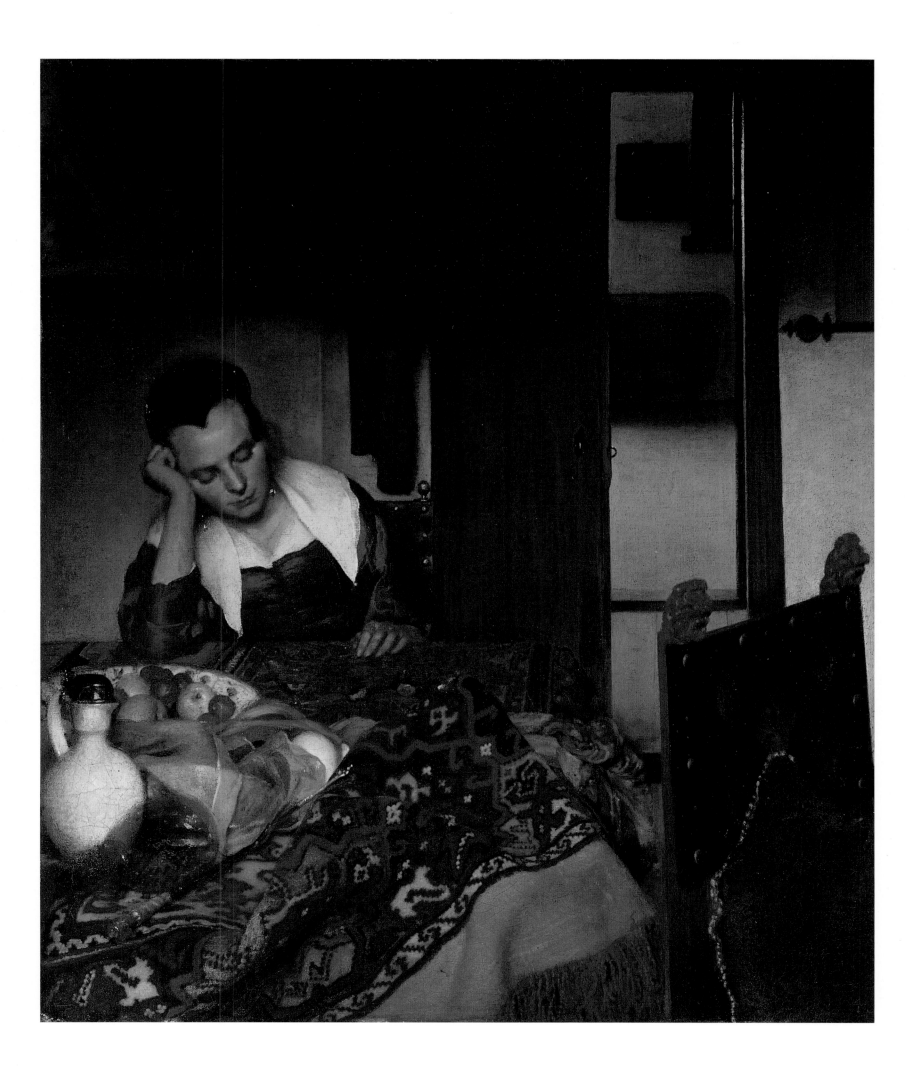

Plate 6

GIRL READING A LETTER AT AN OPEN WINDOW

c. 1657. Oil on canvas, 32 ¾ x 25 ⅜" (83 x 64.5 cm).
Staatliche Kunstsammlungen, Gemäldegalerie, Dresden

Vermeer's genre scenes have a remarkable sense of privacy. The viewer often feels as though he has been allowed to share discreetly in moments of people's lives unfolding in the intimacy of their homes. Here, Vermeer provides a quiet space in the corner of a room behind a rug-draped table for the young woman to read her letter. Light from the open window glows radiantly on her head and shoulders as she intently follows the letter's words. Seen in strict profile, she is unaware that her emotional response is dimly reflected in the windowpanes before her.

This painting has an immediacy that stems from Vermeer's increased interest in naturalistic, and even illusionistic, effects. Not only does he suggest the translucent and reflective qualities of glass, but also the sheen of the woman's lemon yellow sleeves, and the nap of the wool rug, which he accents with colored highlights. The most remarkable illusionistic element, however, is the large, yellowish-green curtain hanging from a rod stretching across the painting. Partly because light falls on its front surface, the curtain seems to belong to the viewer's space, as though it has been pulled aside to reveal this intimate moment in the young woman's life.

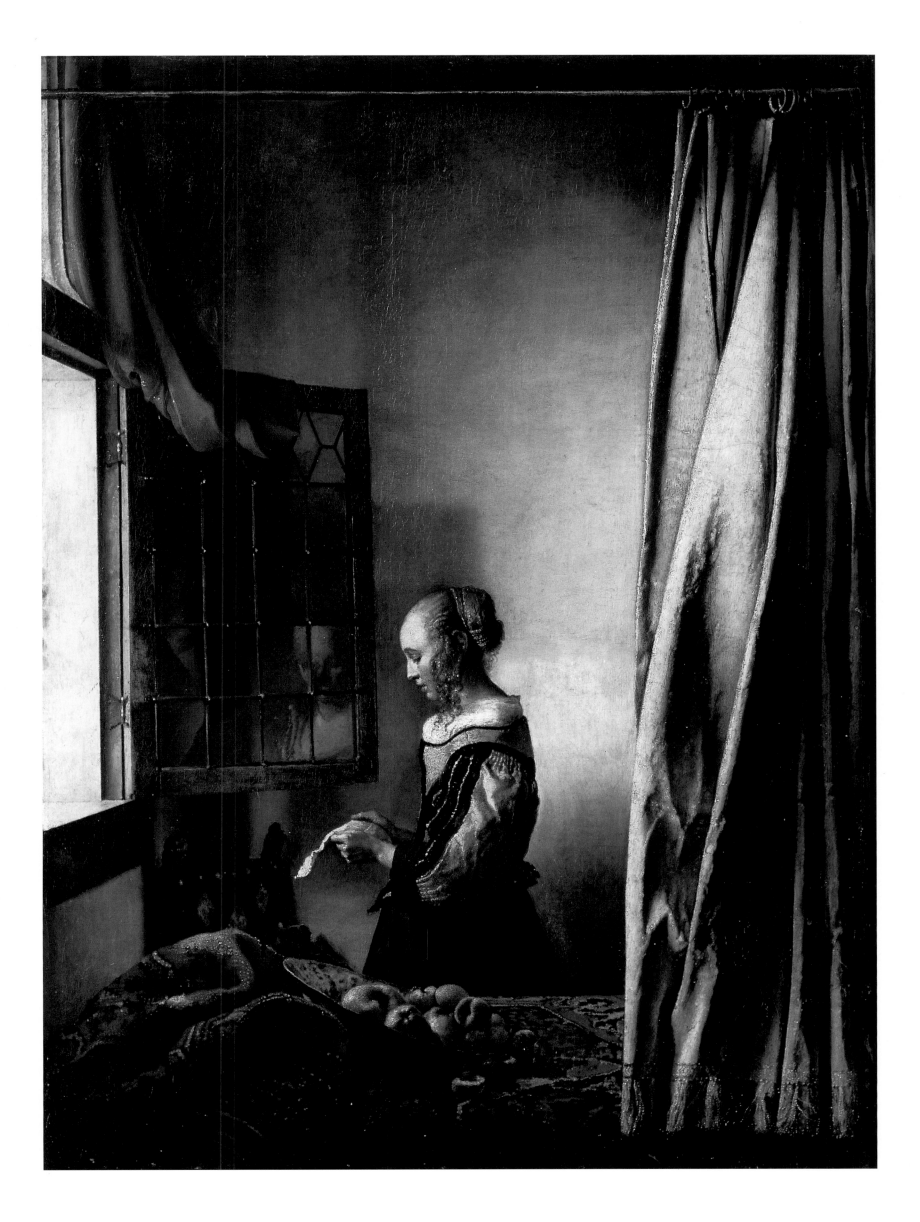

Plate 7

THE LITTLE STREET

c. 1657—1658. Oil on canvas, 21 3/8 x 17 3/8" (54.3 x 44 cm).
Rijksmuseum, Amsterdam

The Little Street seems so real that one can almost imagine Vermeer recording the view from his studio window. Indeed, scholars have long sought to identify its location in Delft, a futile effort since Vermeer apparently combined architectural elements from various locations to create this harmonious streetscape. As with Pieter de Hooch's depictions of Delft courtyards (see Fig. 9), Vermeer has portrayed a world of domestic tranquillity, where women and children go about their daily lives within the reassuring presence of their homes. He emphasized the continuity of their world by suggesting the aged appearance of these sixteenth-century dwellings, where bricks have settled and been repointed, where tiles over the passageway connecting the buildings have fallen away, and where, over the years, the backs of family members seated on the bench below the green shutters have darkened the building's whitewashed facade.

Vermeer's painting seems simple and direct. No distinctive or unusual activity, such as, for example, a figure gesturing out of a window or wandering along the cobblestone street, commands the viewer's attention. Instead, Vermeer has carefully composed his scene to suggest ideals of domestic virtue important to Dutch society, where women, industriously pursuing their needlework or conscientiously undertaking household chores, provide a safe and loving haven for the children in their care.

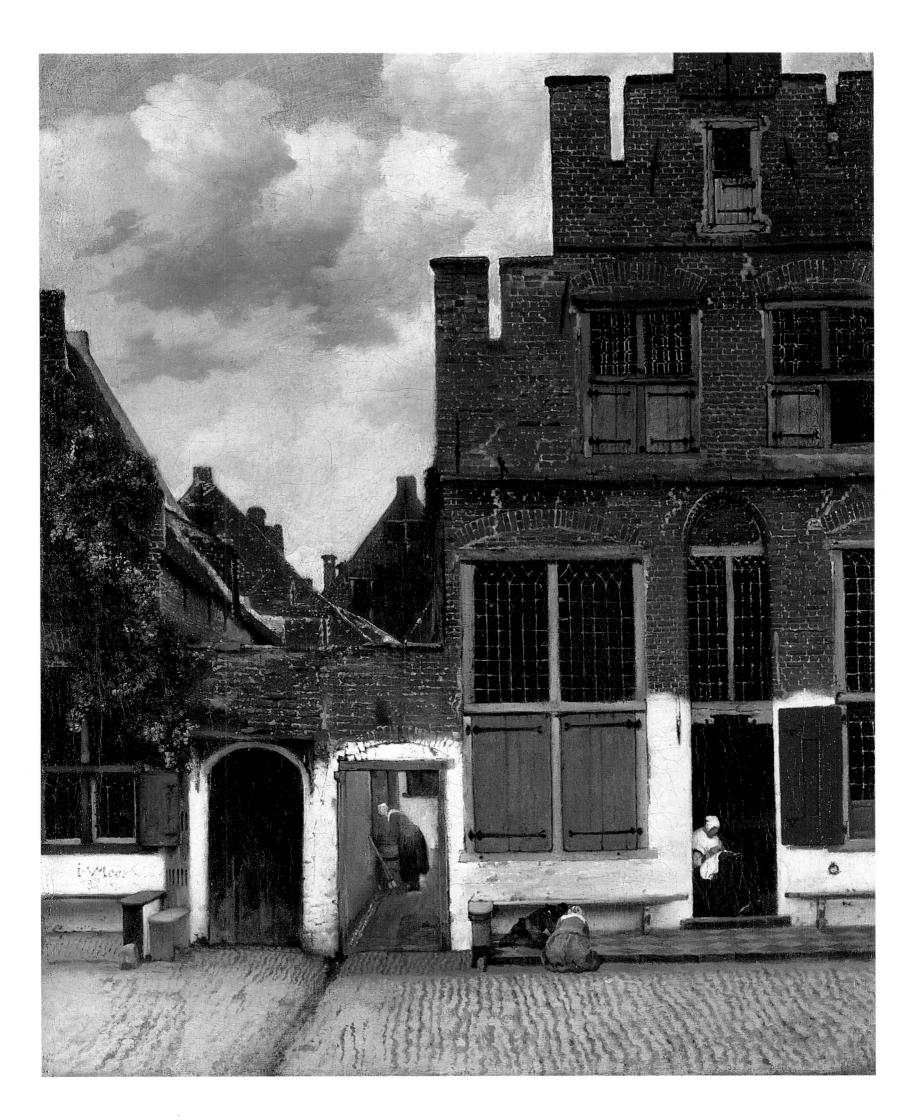

Plate 8

OFFICER AND LAUGHING GIRL

c. 1658–1660. Oil on canvas, 19 ⅞ x 18 ⅛" (50.5 x 46 cm).
The Frick Collection, New York

In this radiant painting a young woman gazes happily into the eyes
of a red-cloaked soldier sitting across from her. Vermeer uses the
sunlight falling on her to enliven her expression and to create shim-
mering specular highlights on the yellow strips of her sleeves and on
the lion-head-finial chair.

Vermeer may have been inspired to paint this scene by Pieter
de Hooch, who, in the mid-to-late 1650s, often depicted soldiers
relaxing in a domestic setting (Fig. 16). Vermeer, however, brought
an added intensity to the figures' relationship by bringing them to
the immediate foreground. He furthered this effect by exaggerating
the differences in scale between the figures and by dressing the
soldier in deep red, a color associated with passion and power. He
also used the dramatic perspective of the window frame to draw the
viewer into the scene and to activate the space between the figures.

Vermeer painted the map representing the provinces of Holland
and West Friesland so accurately that it has been identified as one
published in the Netherlands around 1620. Nevertheless, he has
imaginatively colored the map, painting the land blue, to relate to
the color harmonies of the painting. Its actual appearance would
probably have been similar to that seen in *Woman in Blue Reading
a Letter* (Pl. 15), where the same map is depicted with a muted,
ocher tonality.

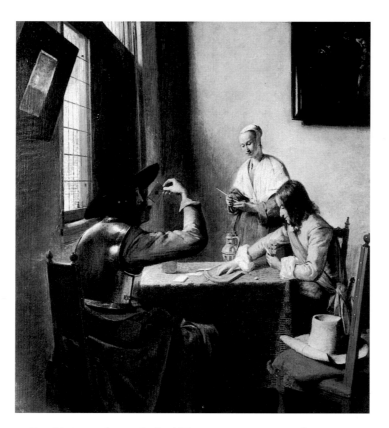

*Fig. 16. Pieter de Hooch, Card Players. c. 1656–58. Oil on canvas,
19 ⅝ x 17 ⅞" (50 x 45.5 cm). Private collection, Switzerland*

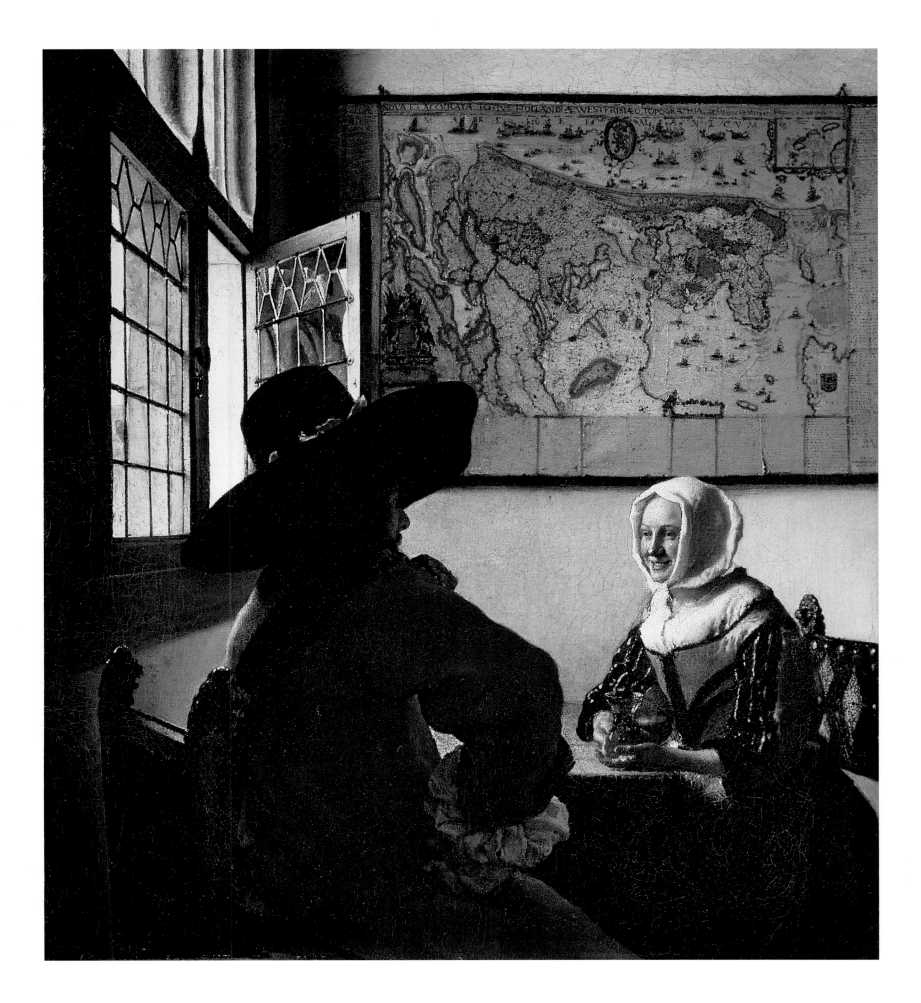

Plate 9

THE MILKMAID

c. 1658—1660. Oil on canvas, 17 ⅞ x 16 ⅛" (45.5. x 41 cm).
Rijksmuseum, Amsterdam

As she stands before a rough, white-plastered wall, the milkmaid
assumes a dignity far in excess of the simple task she performs. She
emanates a wholesomeness and a sense of moral purpose that stem
from the steadfastness of her gaze as she carefully measures the milk
into an earthenware bowl. These qualities also derive from the sheer
physical power of her being, which Vermeer emphasized through
the unusually bold modeling of her figure. Finally, they are aug-
mented by the perspective of the window, whose orthogonals recede
to a vanishing point just above her right hand, a placement that
reinforces the significance, and permanence, of her gesture.

Vermeer was a master at using light to enhance the mood and
character of his images. Here, for example, he differentiated light on
the rear wall to enhance the figure's three-dimensionality. He juxta-
posed the bright yellow of the milkmaid's right shoulder to the
shaded portion of the wall, while placing her shaded left shoulder
against a bright backdrop. He then painted a white contour line
along this shoulder to accentuate the figure's strong silhouette.

The most dramatic light effects occur on the table, where
Vermeer evoked the textures of the earthenware bowl, jug, and bas-
ket, as well as the freshness of the breads, with an array of specular
highlights. He created these with a complex layering of paints,
often applied wet-in-wet.

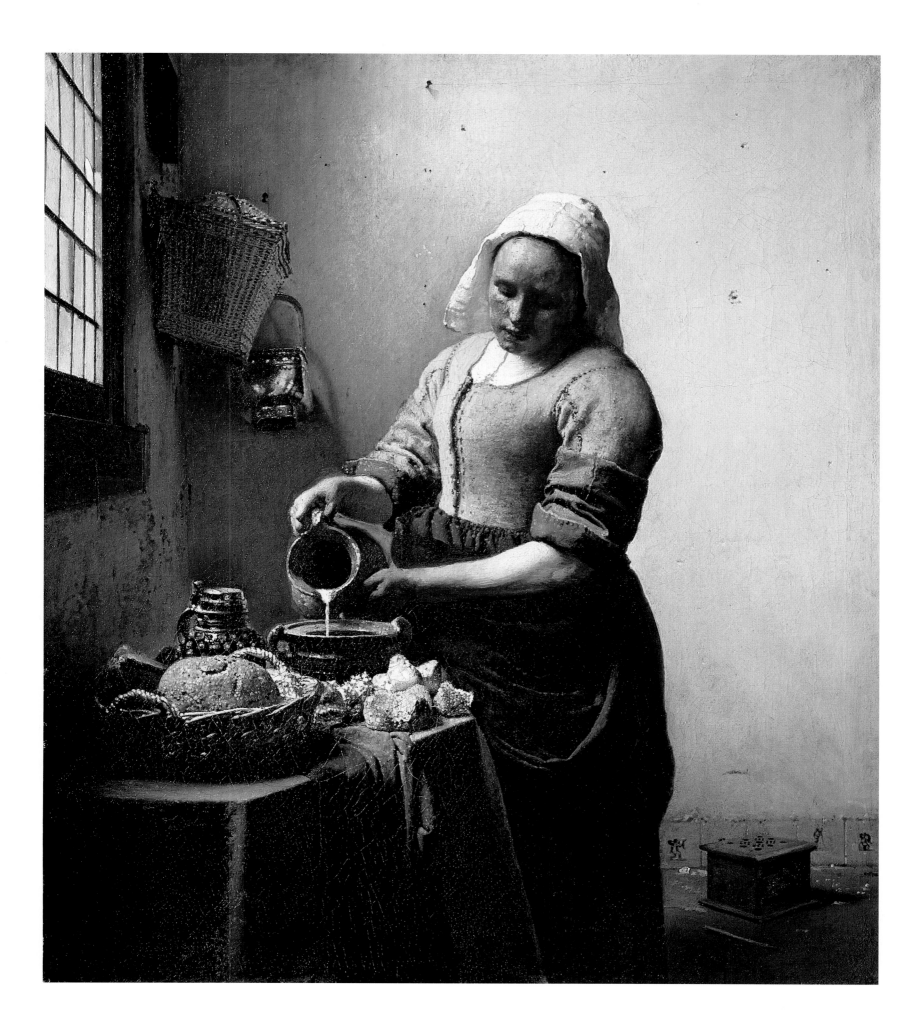

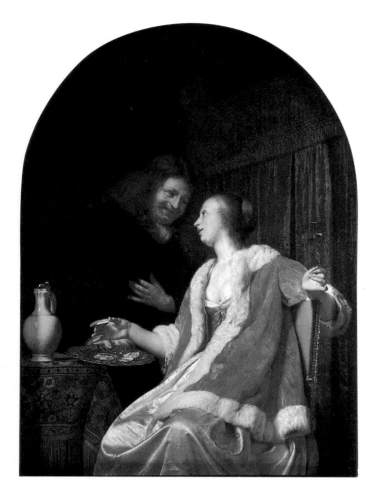

Fig. 17. Frans van Mieris, The Oyster Meal. *1661.*
Oil on panel, 32 ¹/₁₆ x 49" (81.5 x 124.5 cm).
Mauritshuis, The Hague

Plate 10

THE GLASS OF WINE

c. 1658–1660. Oil on canvas, 25 ⅝ x 30 ¼" (65 x 77 cm).
Staatliche Museen zu Berlin, Preussischer Kulturbesitz, Gemäldegalerie

In the late 1650s and early 1660s, inspired by the paintings by
Pieter de Hooch (see Fig. 9) and Frans van Mieris (1635–1681)
(Fig. 17), Vermeer turned his attention to depictions of the social
interaction of upper-class men and women. He set this couple with-
in an expansive interior, using perspective to define the spatial
arrangement. Less evident, however, is the nature of the couple's
relationship. Despite the presence of wine and music, the mood
seems somber and the emotional bond distant.

Plate 11 (overleaf)

THE GIRL WITH THE WINEGLASS

c. 1659–1660. Oil on canvas, 30 ¾ x 26 ⅜" (78 x 67 cm).
Herzog Anton Ulrich-Museum, Braunschweig

Painted in a more refined style than the previous work, this painting
depicts a scene of seduction, as an elegant young man obsequiously
encourages a young woman to enjoy a glass of wine. However, the
knowing smile on her face as she turns to the viewer indicates that
he, rather than she, is the one being seduced.

Plate 12 (overleaf)

GIRL INTERRUPTED AT HER MUSIC

c. 1660–1661. Oil on canvas, 15 ½ x 17 ½" (39.3 x 44.4 cm).
The Frick Collection, New York

Although this painting is in poor condition and has been overpaint-
ed in certain areas (the birdcage, for example, is not original), the
still life has been well preserved. Here, Vermeer suggests that an
interruption has occurred through the turn of the young woman's
head, a compositional device that gives the scene an unusual sense
of expectancy.

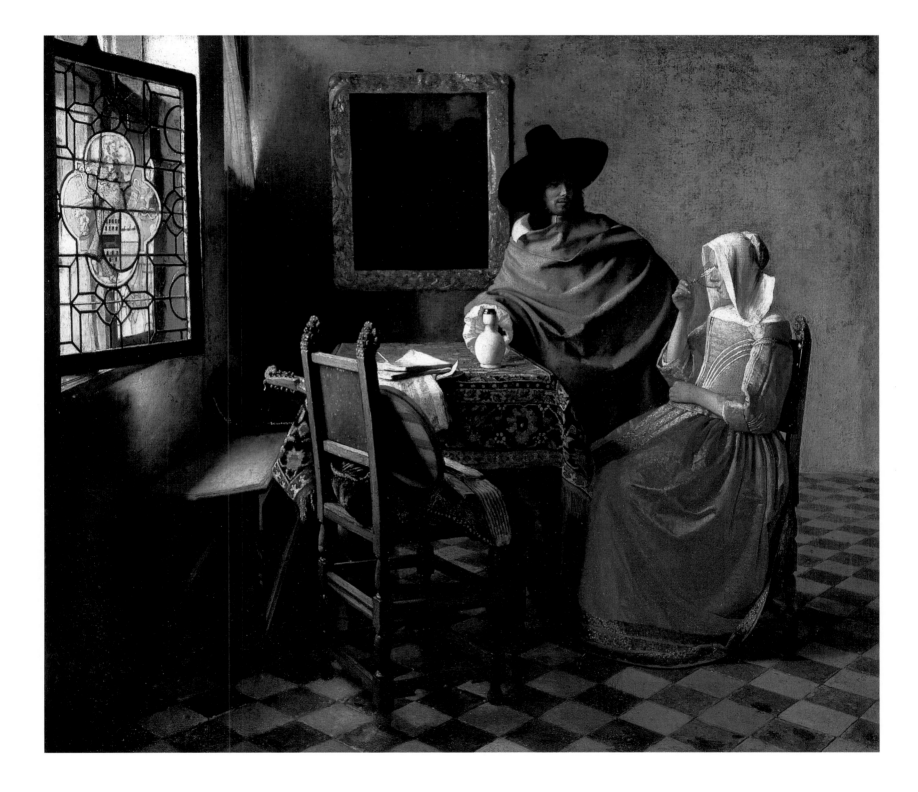

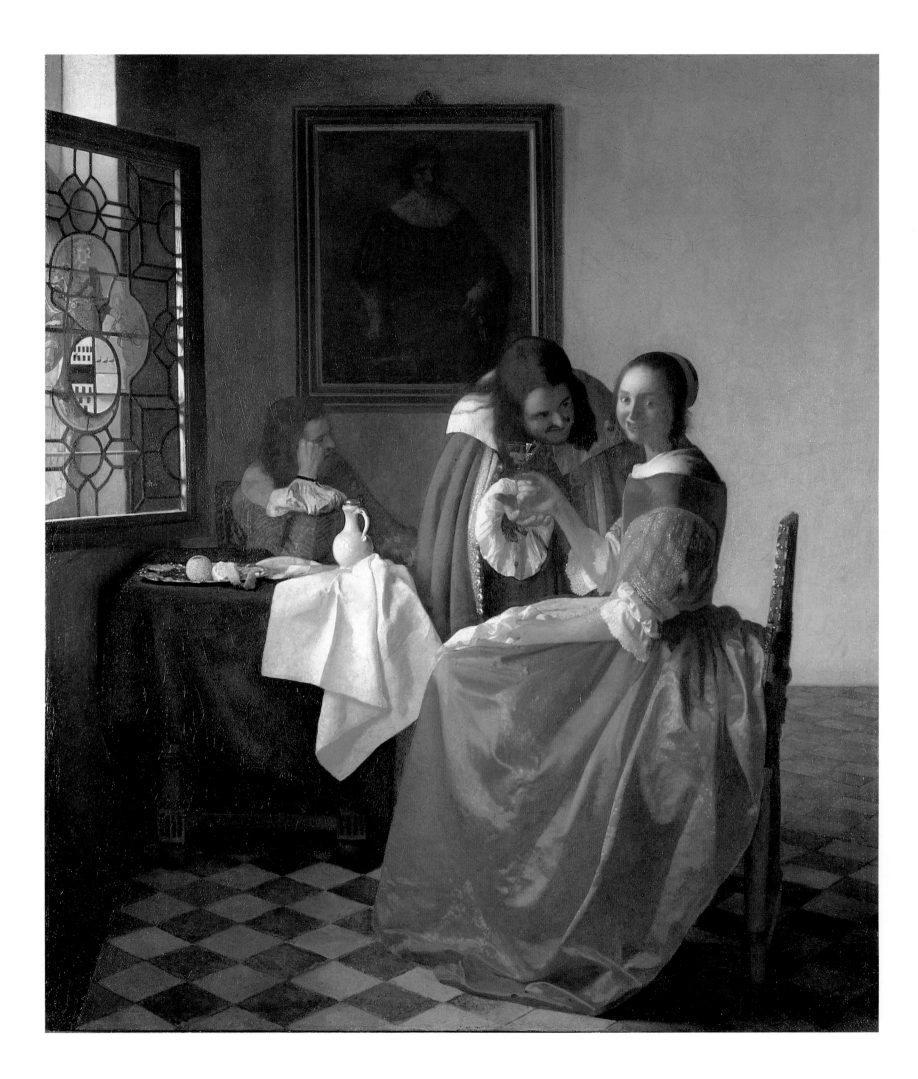

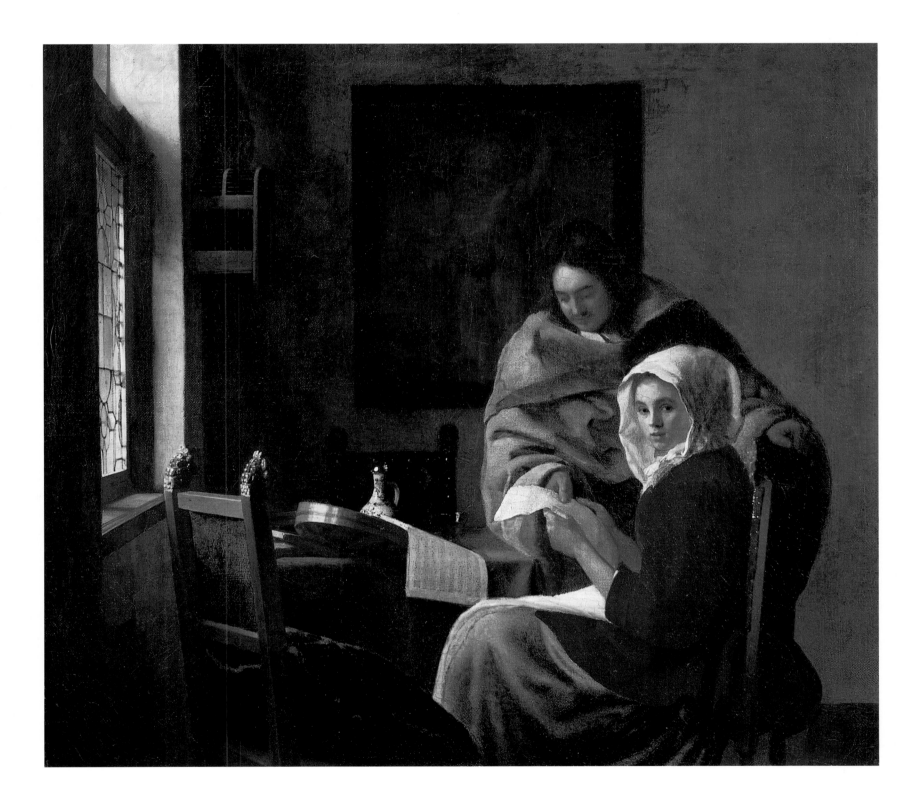

Plate 13

VIEW OF DELFT

c. 1660—1661. Oil on canvas, 38 ³/₄ x 46 ¹/₄" (98.5 x 117.5 cm).
Mauritshuis, The Hague

Vermeer has depicted Delft from across its harbor, where transport
boats would unload after navigating inland waterways from the
ports of Rotterdam and Schiedam (Fig. 18). Beyond the frieze of
Delft's protective walls and massive gates, which Vermeer cast in
shadow to suggest their age and venerability, the inner city glows in
the warmth of bright sunshine. Rising above all is the tower of the
Nieuwe Kerk, burial place of the Princes of Orange and the city's
symbolic core.

The painting's stillness creates an aura of veneration for the city
and its proud history. Although a few figures stand on the fore-
ground shore, the harbor remains calm, with long shadows forming
visual bridges to the city beyond.

The painting's forcefulness stems in part from its large scale,
which allows the viewer to enter into the space, but also from the
tangible illusion of reality. Vermeer achieved this through his mas-
tery of light and his ability to create textural effects. The buildings,
for example, take on a physical presence because of Vermeer's sug-
gestive manner of juxtaposing small dots of unmodulated colors
with touches of the brush. He used a similar technique to suggest
the reflection of water on the sides of the boats. These diffused
highlights are comparable to those seen in a camera obscura, an
indication that he may have conceived this painting with the aid
of this optical device.

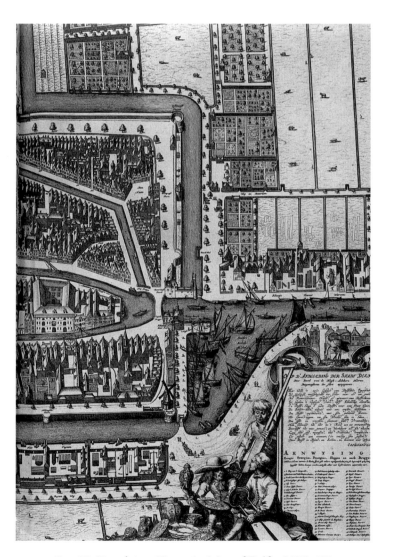

Fig. 18. Detail from Figurative Map of Delft. *1675—78.*
National Gallery of Art Library, Washington, D.C.

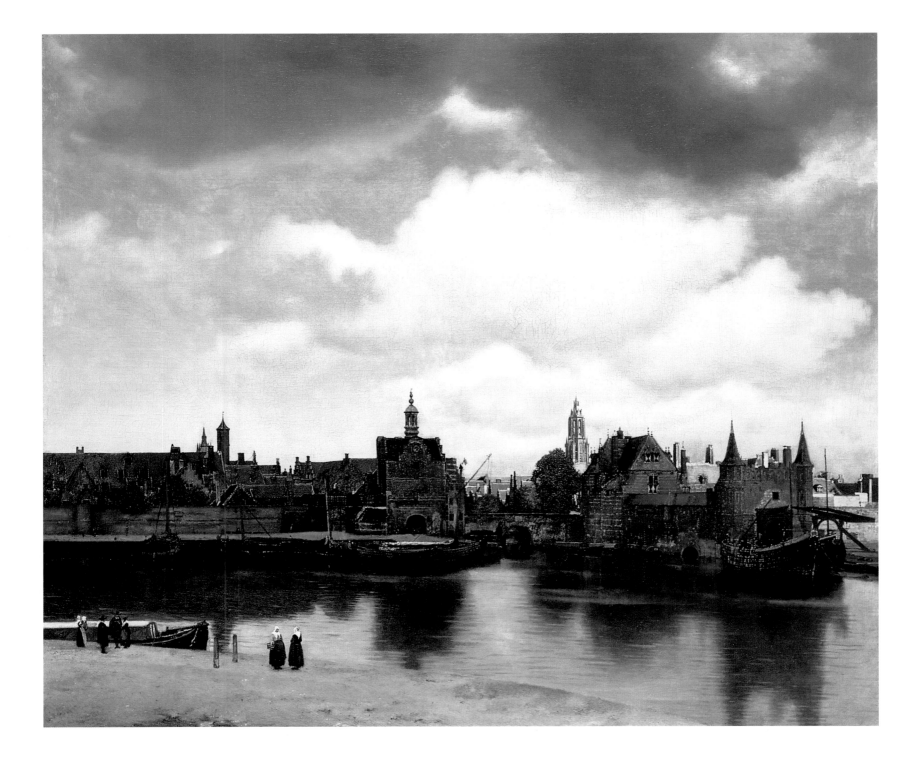

Plate 14

A LADY AT THE VIRGINAL WITH A GENTLEMAN (THE MUSIC LESSON)

c. 1662–1664. Oil on canvas, 28 ⅞ x 25 ⅜" (73.3 x 64.5 cm). The Royal Collection © Her Majesty Queen Elizabeth II

Situated at the far side of an expansive room is an intimate musical ensemble, where a young woman plays a virginal while an elegant gentleman stands near, seemingly transfixed by its sonorous chords. Nestled behind a large foreground table and blue chair, the two figures exist in a private world, with music communicating the solace and joy promised by the inscription on the virginal's lid: *"Musica letitiae co[me]s medicina dolor[um]"* (Music: companion of joy, balm for sorrow).

Beyond solace and joy, however, music also alludes metaphorically to the harmony of two souls in love, which Vermeer suggests by placing an unattended bass viol on the floor before the couple. The juxtaposition of the two instruments, one being played and the other not, relates to an emblem by Jacob Cats, *"Quid Non Sentit Amor"* (Fig. 19), that describes how the sound of one instrument resonates on the other just as two hearts can exist harmoniously even if separated.

Vermeer thoughtfully conceived this work to focus on the two figures and to reinforce the bonds that unite them. For example, the orthogonals of the perspective system reinforce the woman's central thematic importance by converging at her sunlit left sleeve. Furthermore, Vermeer strengthened the psychological bonds uniting them through the measured shapes of the virginal, mirror, and black-framed painting, which establish a complex visual framework for their relationship.

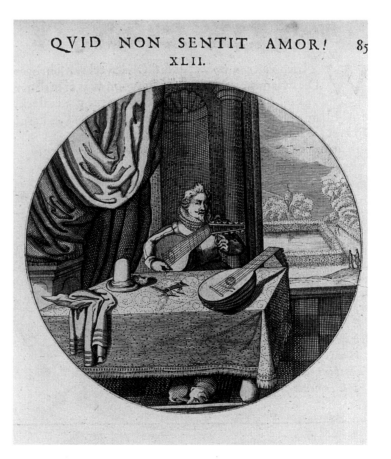

Fig. 19. "Quid Non Sentit Amor," from Jacob Cats, Proteus. Engraving, 4 ⅞ x 4 ⅞" (12.5 x 12.5 cm). National Gallery of Art Library, Washington, D.C.

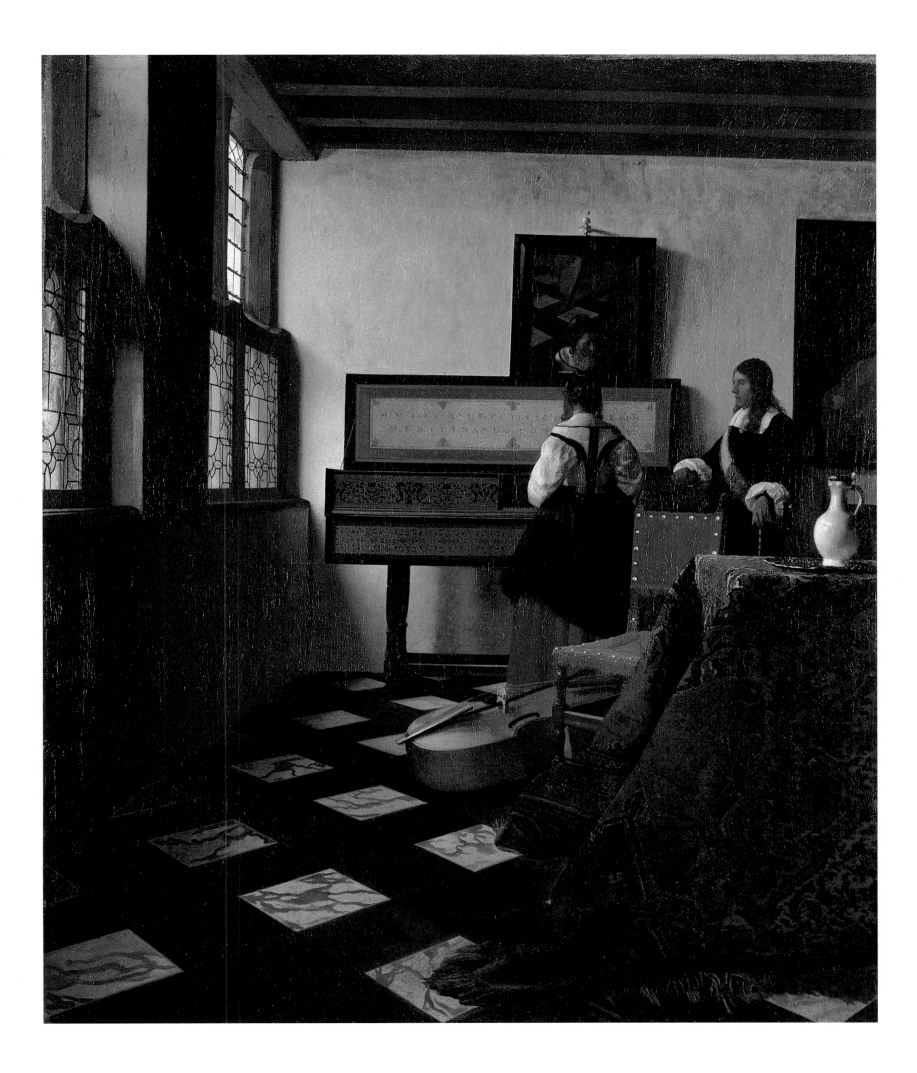

Plate 15

WOMAN IN BLUE READING A LETTER

c. 1663–1664. Oil on canvas, 18 $\frac{1}{4}$ x 15 $\frac{3}{8}$ " (46.5 x 39 cm).
Rijksmuseum, Amsterdam

Vermeer conceived many of his paintings around letters, capturing
the sense of expectancy elicited by these intimate communications.
Here, Vermeer conveyed the depth of the young woman's feelings
through her tender expression. She, with lowered eyes and half-
opened mouth, firmly holds the unfolded letter in both her hands
while tightly clasping her arms to her side. Immersed in her private
world, she is unaware of the presence of the viewer, who, as though
coming unexpectedly upon an intimate scene, instinctively holds
back, reluctant to intrude.

 Although the painting depicts but a fleeting instant in this
woman's life, Vermeer extends the moment, lending great dignity
and significance to the scene. To achieve this result he suppressed
the narrative, providing little more than a few intriguing hints about
the woman's relationship with her absent loved one: a map on the
rear wall, perhaps alluding to travel; the fullness of her shape, possi-
bly indicating pregnancy; and a second sheet of the letter lying on a
strand of pearls spread out on the table, presumably because it
arrived unexpectedly while she was adorning herself. He also
extended the narrative moment compositionally. For example, he
positioned the woman before the map so that its dark bar passes
directly behind her hands, thus establishing a visual connection
between her hands and the horizontal bar that visually locks
them in space.

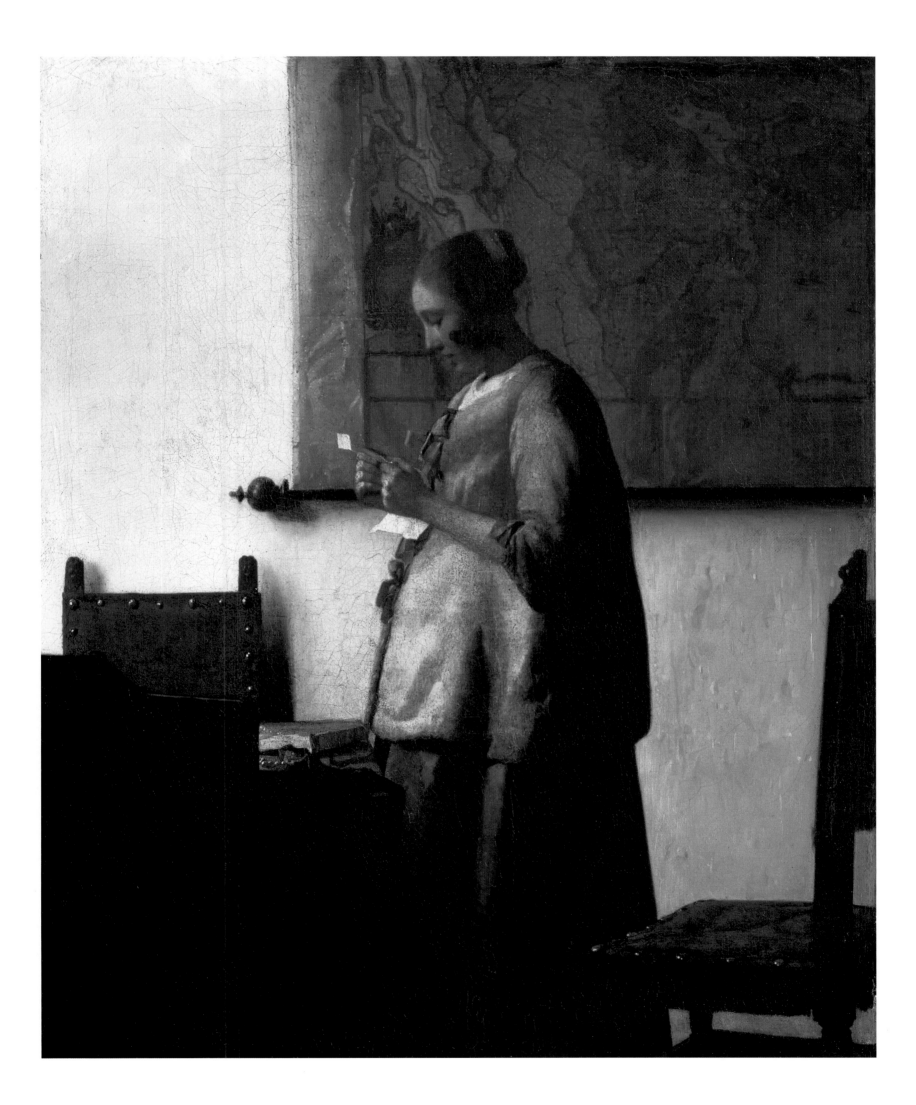

Plate 16

WOMAN HOLDING A BALANCE

*c. 1664. Oil on canvas, 16 ³/₄ x 15″ (42.5 x 38 cm). Widener
Collection, © 1997 Board of Trustees, National Gallery of Art,
Washington, D.C.*

Vermeer's unusual sensitivity to light enhances both the physical
and the psychological reality of his scenes. Nowhere in his *oeuvre* is
his mastery more evident than in this dimly lit interior, where a
young woman stands serenely waiting for her balance to come to
rest. For example, he has recorded how light passes by the orange
curtain hanging before the window, noting that it filters through
the edges of the curtain to create a subtle orange glow on the gray
wall behind. He then used light to focus on significant composi-
tional elements in the painting: the jewelry box on the table with its
strands of gold beads and pearls; the fingers of the woman's poised
right hand; and the scale she holds. The woman's left arm resting
on the table extends the flow of light, carrying it upward past her
fur-trimmed jacket until it comes to rest on her serene countenance.

The thematic connection between the woman's balance and the
painting of the *Last Judgment* hanging directly behind her signifies
that the artist conceived the scene allegorically. Standing before a
jewelry box draped with gold and pearls, the woman waits for her
empty scales to come to rest. Her calm expression indicates that
she is aware that she must balance her life by moderating her own
actions, ensuring that transient worldly treasures do not outweigh
lasting spiritual concerns.

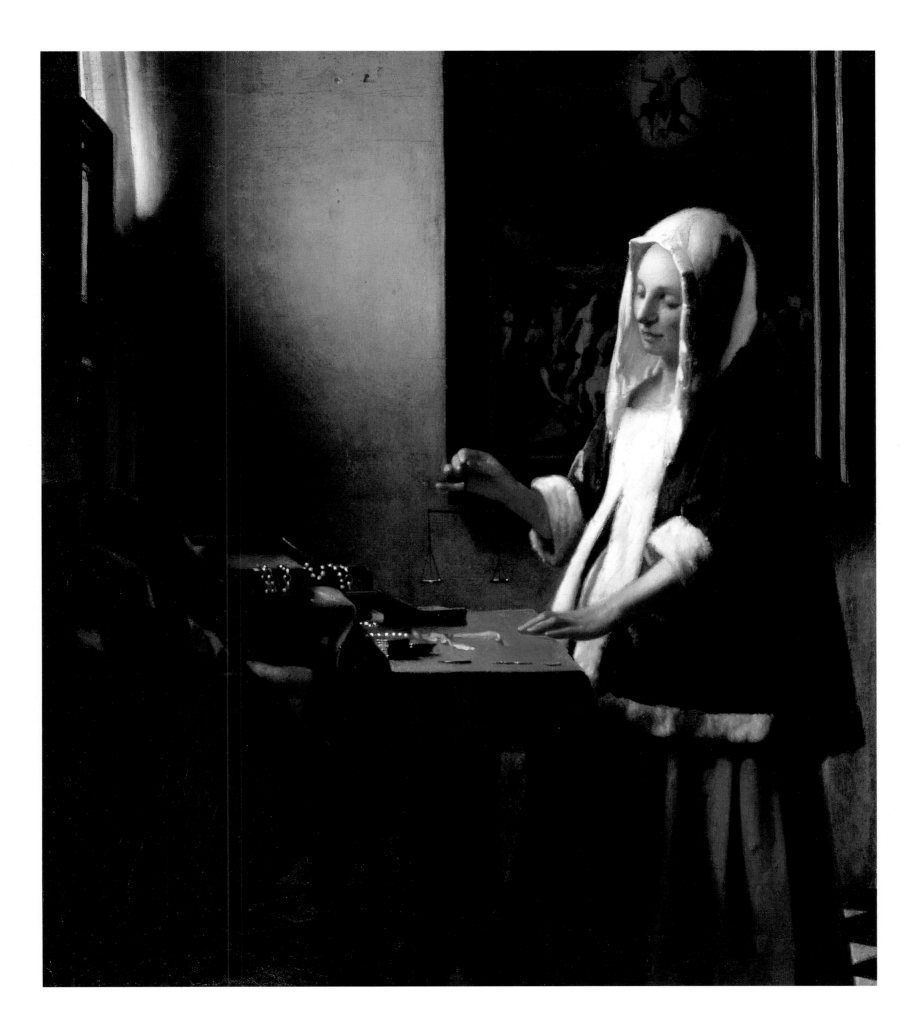

Plate 17

YOUNG WOMAN WITH A WATER
PITCHER

c. 1664–1665. Oil on canvas, 18 x 16″ (45.7 x 40.6 cm).
The Metropolitan Museum of Art, New York. Gift of Henry G.
Marquand, 1889

Vermeer focused many of his scenes on a female figure lost in
thought while in the midst of a daily activity. He discovered in such
quiet moments of contemplation, when one gazes outward but
looks within, a window into an individual's spiritual nature. Here,
the woman's reverie occurs as she stands near the corner of a room,
holding the frame of a leaded-glass window in one hand and a
water pitcher in the other. Partially because of the fluidity of her
pose, but also because of the gentleness of her expression and the
serenity of the deep blues of her dress, she communicates a sense of
purity and inner peace.

Vermeer, however, also understood the importance of the
woman's environment for conveying mood. Radiant light, welcomed
by her open gesture, floods the ordered and harmonious interior.
He has carefully adjusted the patterns of wall shapes created
between objects, as, for example, those under each of the woman's
arms. These defined patterns help hold the woman's pose in place,
giving it a sense of permanence, both temporally and spatially. He
also included objects with specific symbolic associations, such as
the water pitcher, which alludes to cleansing, and hence purity.
Finally, he adapted his painting techniques to reinforce his thematic
emphasis; the abstract blue patterns in the glass suggest metaphori-
cally that the woman gazes outward without focusing on the objects
before her.

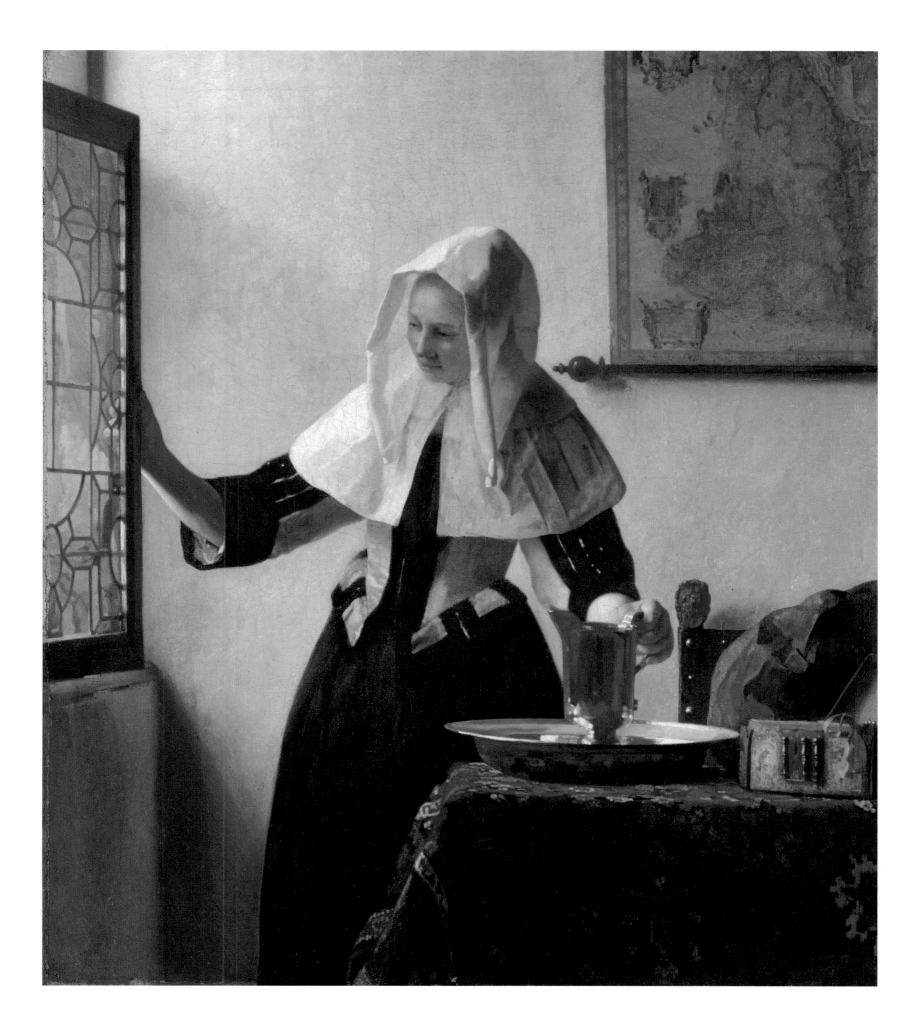

Plate 18

WOMAN WITH A LUTE

c. 1664. Oil on canvas, 20 ¼ x 18" (51.4 x 45.7 cm).
The Metropolitan Museum of Art, New York. Bequest of Collis P.
Huntington, 1925

As this seated young woman tunes her lute while gazing toward a window, she seems lost in thought, only vaguely conscious of the measured sounds from her strings. Indeed, for a painting with a musical theme, the tenor seems extremely quiet, as though we, too, can scarcely hear the muted notes she plays.

Vermeer provided a structural framework for the reflective mood he sought to convey. By placing her off-center, carefully nestled between the large wall map, table, and dark repoussoir of the lion-head-finial chair, he created a private space for her reveries. Moreover, by establishing a close vantage point and a low horizon line for his perspective system, which exaggerates differences in scale between foreground and background objects, he made her seem comparatively small and distant.

Vermeer has not given a precise explanation for the woman's meditative attitude, preferring instead to suggest a mood that has universal resonances. However, he provided two indications that the woman's musing revolves around a distant lover: the map of Europe, which may well allude to foreign travels; and the bass viol dimly visible under the table. The presence of this second instrument relates to an emblem by Jacob Cats (see Fig. 19), which describes metaphorically how the resonance of the strings of one musical instrument are felt in another, just as the heartstrings of two lovers sound as one, even when they are separated.

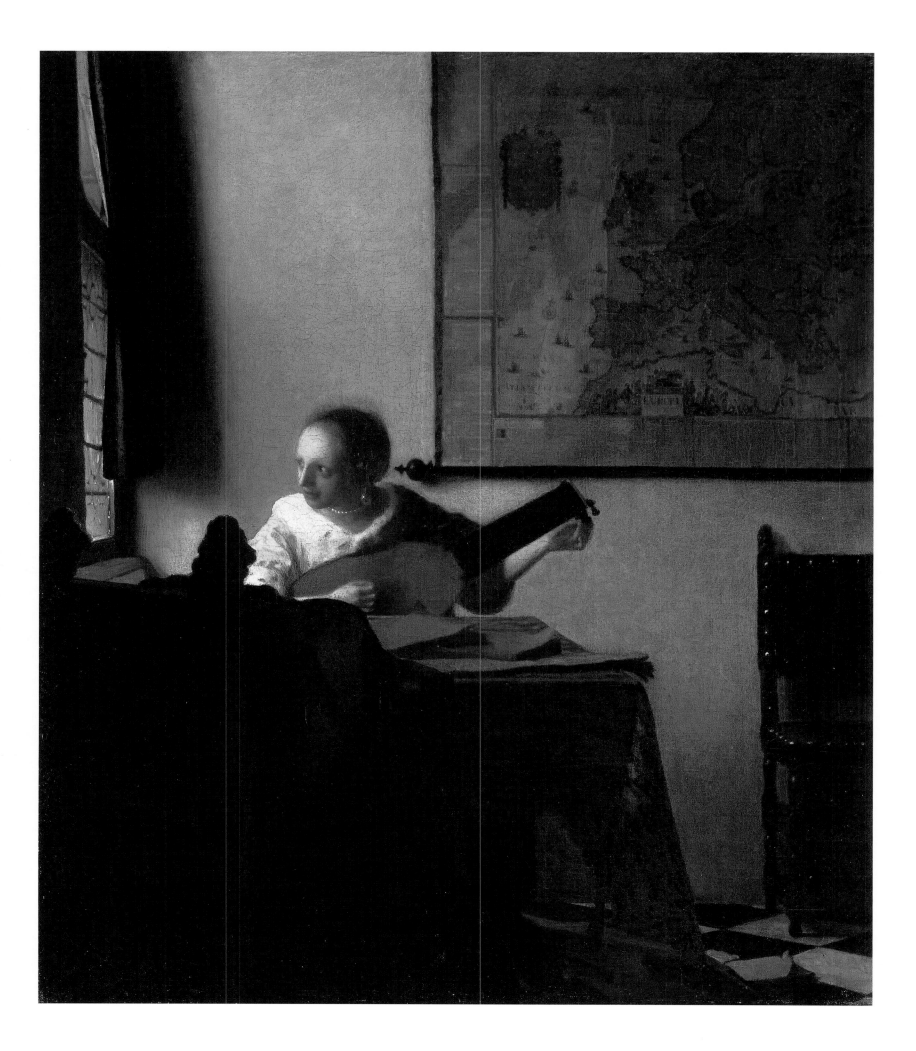

Plate 19

WOMAN WITH A PEARL NECKLACE

c. 1664—1665. Oil on canvas, 21 ⅝ x 17 ¾" (55 x 45 cm).

Staatliche Museen zu Berlin, Preussischer Kulturbesitz, Gemäldegalerie

Pearls have inspired artists throughout history, but Vermeer, more than any other painter, understood how to capture the softly luminous sheen of their surfaces. He also perceived the special aura of pearls, and the complex metaphorical associations given uniquely to them. On the one hand, because of their beauty and preciousness, pearls can be viewed negatively, as indicating the vanity of worldly concerns; on the other, because of their white, flawless luster, pearls also allude to faith, purity, and virginity. Vermeer, realizing that distinctions between these seemingly opposing symbolic meanings are not always clearly evident, created paintings such as *Woman with a Pearl Necklace* where the viewer must confront that delicate balance between earthly vanity and spiritual virtue.

As the woman tautly holds the ribbons of her pearl necklace, she gazes into a mirror, another object imbued with complex moralizing associations; a mirror can symbolize pride, but also truth and self-knowledge. Vermeer provides no explicit commentary about how one should interpret the scene, one of the reasons this work is so endlessly intriguing. Nevertheless, the figure's dignified pose and the flow of light flooding the room do encourage a positive interpretation of the image. Indeed, through these means, as well as through the woman's serene expression, Vermeer infuses the painting with a sense of spiritual purity.

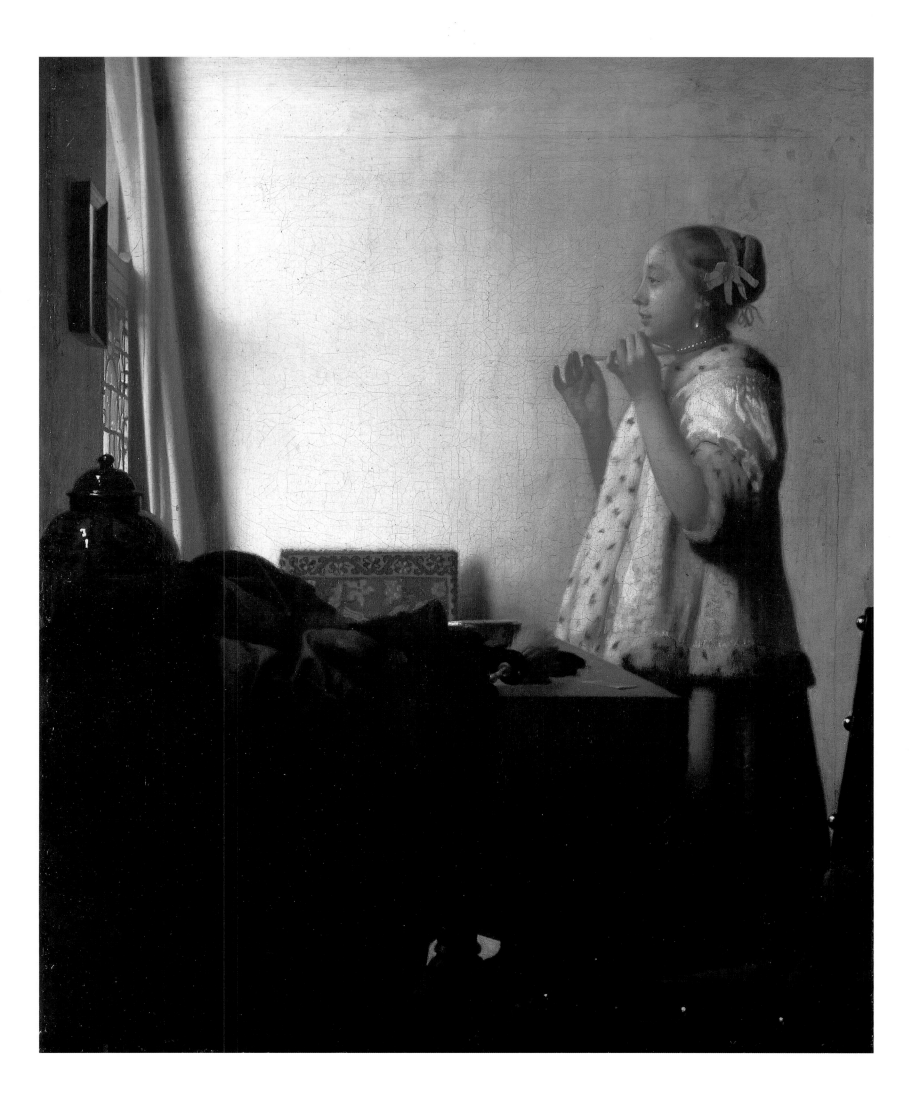

A LADY WRITING

c. 1665–1666. Oil on canvas, 17 ¾ x 15 ¾" (45 x 39.9 cm).
Gift of Harry Waldron Havemeyer and Horace Havemeyer, Jr., in
memory of their father, Horace Havemeyer, © 1996 Board of Trustees,
National Gallery of Art, Washington, D.C.

The inventory made after Vermeer's death lists a number of house-
hold items that appear in his paintings, among them a yellow satin
jacket trimmed with white fur. The appearance of such a garment
in this image may well indicate that the woman at her writing table
is Vermeer's wife, Catharina Bolnes. This theory seems reinforced
by the care with which Vermeer modeled the woman's features.
Moreover, he has emphasized her face by posing her as though she
has just looked up after being interrupted. Nevertheless, since dif-
ferent women wear the same jacket in *Woman with a Pearl Necklace*
(Pl. 19) and *Mistress and Maid* (Pl. 25), the identification cannot
be confirmed.

The painting is an exquisite example of the care Vermeer took to
create a harmonious relationship between his figures and their envi-
ronment. For example, the diagonal fold in the blue tablecloth par-
allels the woman's arm resting on the table, a pattern of diagonals
he continued across the composition with the angled position of
the chair. With a similar concern for the relationship of figural and
still-life elements, he painted the yellow ribbons on the table so that
they follow the contour of the woman's outstretched hand. Finally,
he helped direct the viewer's attention to her letter-writing activity
at the left of the composition through the large horizontal shape of
the still-life painting hanging above the table.

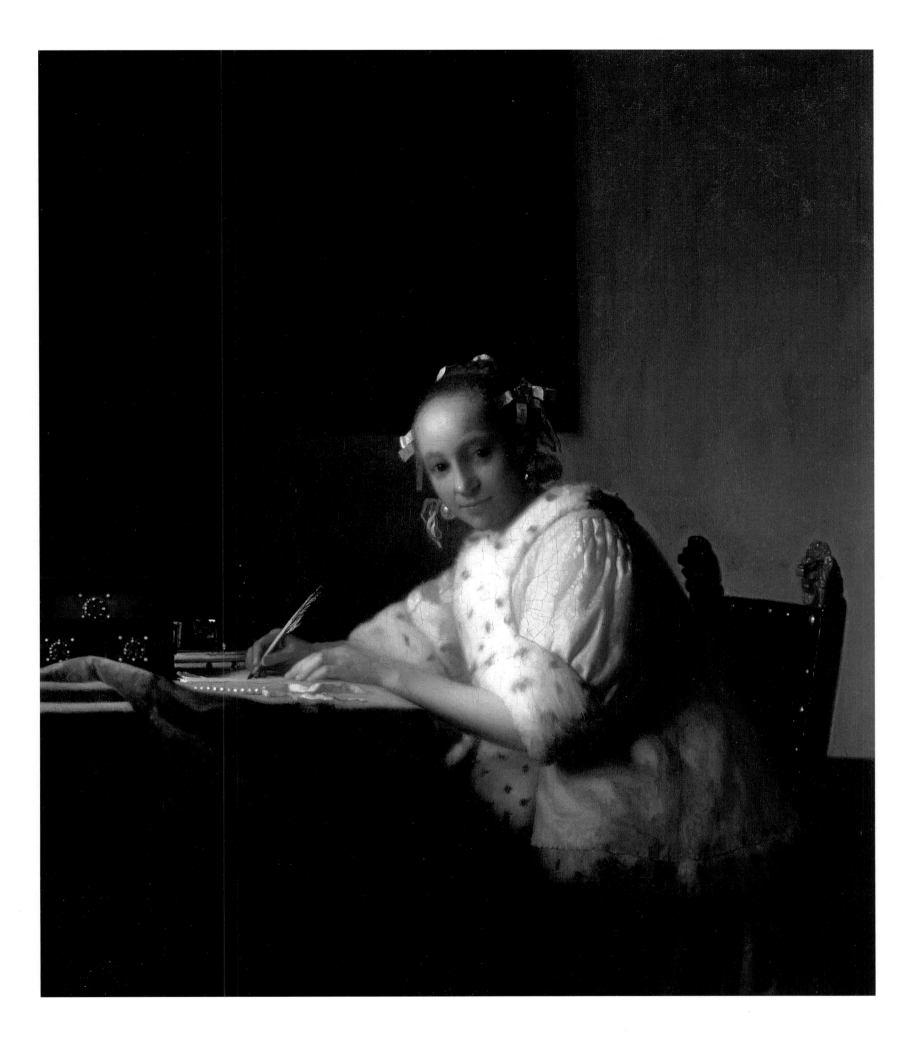

GIRL WITH A PEARL EARRING

c. 1665—1666. Oil on canvas, 18 ¼ x 15 ¾″ (46.5 x 40 cm).
Mauritshuis, The Hague

Here, in one of Vermeer's most engaging images, a young girl dressed in an exotic turban turns and gazes at the viewer. Her liquid eyes and half-opened mouth impart the immediacy of her presence, yet her purity and her evocative costume give her a lasting quality, unconstrained by time or place.

The relatively large scale of this figure reveals how Vermeer enhanced the sense of realism through his expressive paint techniques. For example, he enlivened the young girl's half smile with two small white dots on either side of her mouth, echoing the highlights in her eyes. He also ingeniously used his paints to capture the effect of light falling across her features, turban, and ocher-colored jacket. He evoked the delicacy of her skin with a soft contour for her cheek, which he created by extending a thin glaze slightly over the edge of the thick impasto defining the flesh color. He indicated reflected light from the white color in the pearl earring, but also, and more subtly, in the shadows on her left cheek. Finally, he painted the shaded portion of the blue turban by covering a black underpaint with freely applied glazes of natural ultramarine.

Despite the feeling of immediacy Vermeer thus creates, the young girl's idealized image conveys a sense of timeless beauty. Vermeer worked as a classicist, purifying his images to express lasting rather than transient qualities of life.

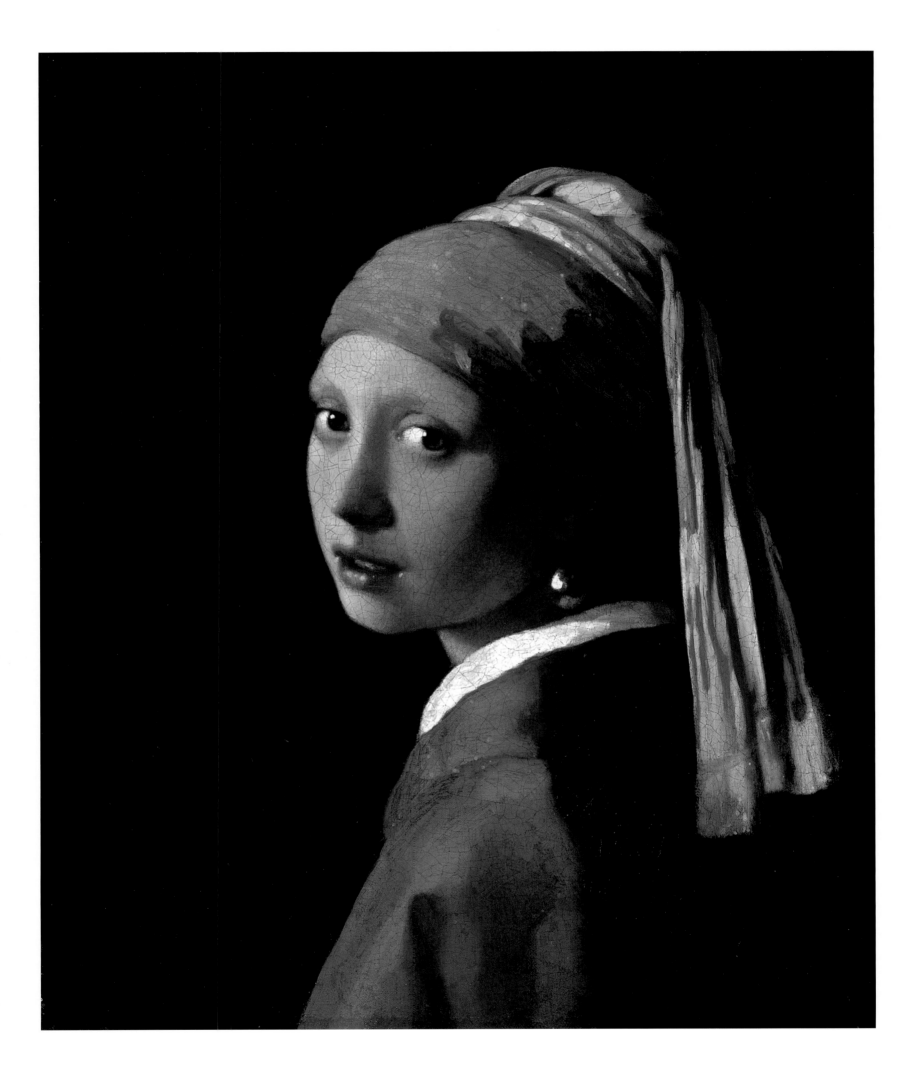

Plate 22

THE CONCERT

c. 1665–1666. Oil on canvas, 28 ½ x 25 ½" (72.5 x 64.7 cm).
Isabella Stewart Gardner Museum, Boston

Music played an important function in upper-middle-class Dutch households, for it facilitated polite social contact between the sexes. If one judges from the number of contemporary books written for soloists, duets, or small ensembles (Fig. 20), *The Concert* depicts a scene that would have been frequently encountered in Vermeer's day. Lyrics accompanying the music ranged from the spiritual to the bawdy, and often centered on love, describing both its sweetness and its pain.

Vermeer placed his three musicians on the far side of an expansive room, each intently involved in playing his or her part. While a young woman sits at the harpsichord and her male accompanist plays the lute, a standing woman sings as she beats time with her right hand, a gesture Dutch artists frequently used to indicate moderation.

Hanging on the rear wall is a contrasting scene of music and love, Dirck van Baburen's *The Procuress* (see Fig. 6), which belonged to Vermeer's mother-in-law, Maria Thins. He undoubtedly included this scene of mercenary love as a thematic contrast to the harmonious ensemble below. A comparable contrast exists with the dark, ominous landscape hanging at the left and the light-filled, arcadian scene depicted on the lid of the harpsichord.

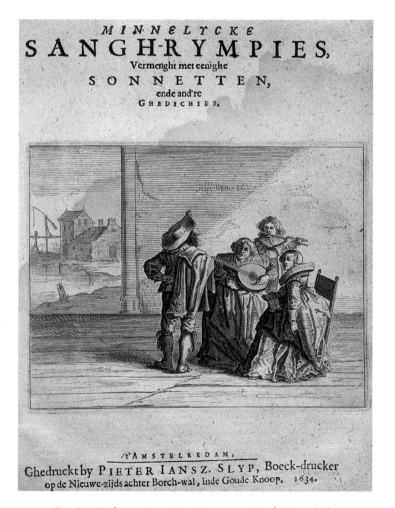

Fig. 20. Title page from Jan Hermansz. Krul, Minnelycke sangh-rympies. *Engraving, 8 ¾ x 6 ½" (22 x 16.5 cm).*
National Gallery of Art Library, Washington, D.C.

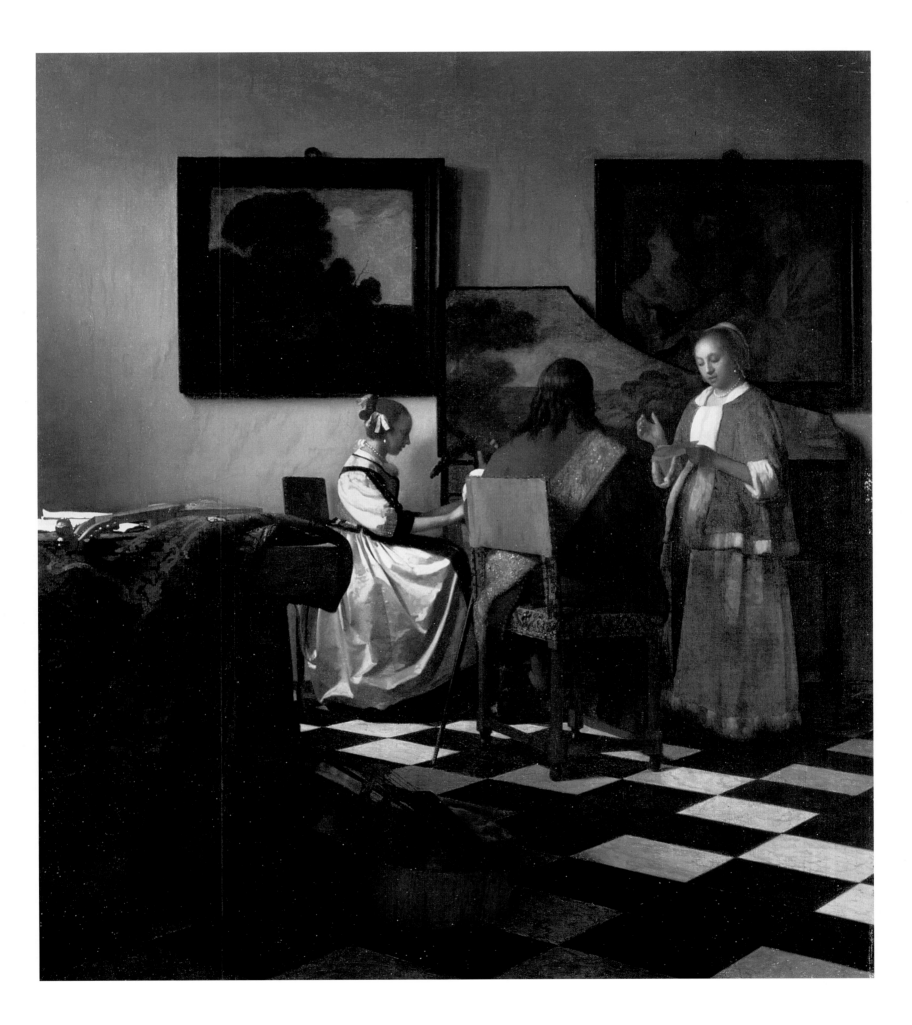

Plate 23

GIRL WITH THE RED HAT

c. 1665–1666. Oil on panel, 9 ⅛ x 7 ⅛" (23.2 x 18.1 cm).
Andrew W. Mellon Collection, © 1996 Board of Trustees, National
Gallery of Art, Washington, D.C.

Vermeer was unusually sensitive to the role color plays in creating compositional accents or establishing mood. For example, the primary palette of yellow and blue he used in many of his paintings enhanced the feeling of serenity he often sought. In this instance, however, he wanted the young girl to sparkle with vibrancy and life. Thus, he placed the flame red hat smartly on her head, its outer edge almost fluorescent in brilliance as light passes through its feathery forms. The turquoise highlight at her eye and a pink highlight in her half-opened mouth animate her expression, reinforcing the impression that she has just turned to gaze at the viewer. The yellow accents on her blue garment create a daring combination of primary colors that add visual intensity to the image.

Vermeer heightened the sense of immediacy with his remarkably free handling of paint, particularly evident in the diffused highlights on the lion-head finials. This unusual technique is similar to optical effects seen in an unfocused camera obscura image, which suggests that Vermeer emulated the qualities of its image when creating the spontaneous impression of this work.

Girl with a Flute (Fig. 21) is another small, bust-length figure study on panel that is similar to *Girl with the Red Hat*. Although it also depicts a young woman in exotic costume, the attribution of the painting is not certain, partially because the image lacks the refinement of Vermeer's touch.

Fig. 21. Attributed to Johannes Vermeer, Girl with a Flute.
Probably 1665/1670. Oil on panel, 7 ⅞ x 7" (20 x 17.8 cm).
Widener Collection, © 1997 Board of Trustees,
National Gallery of Art, Washington, D.C.

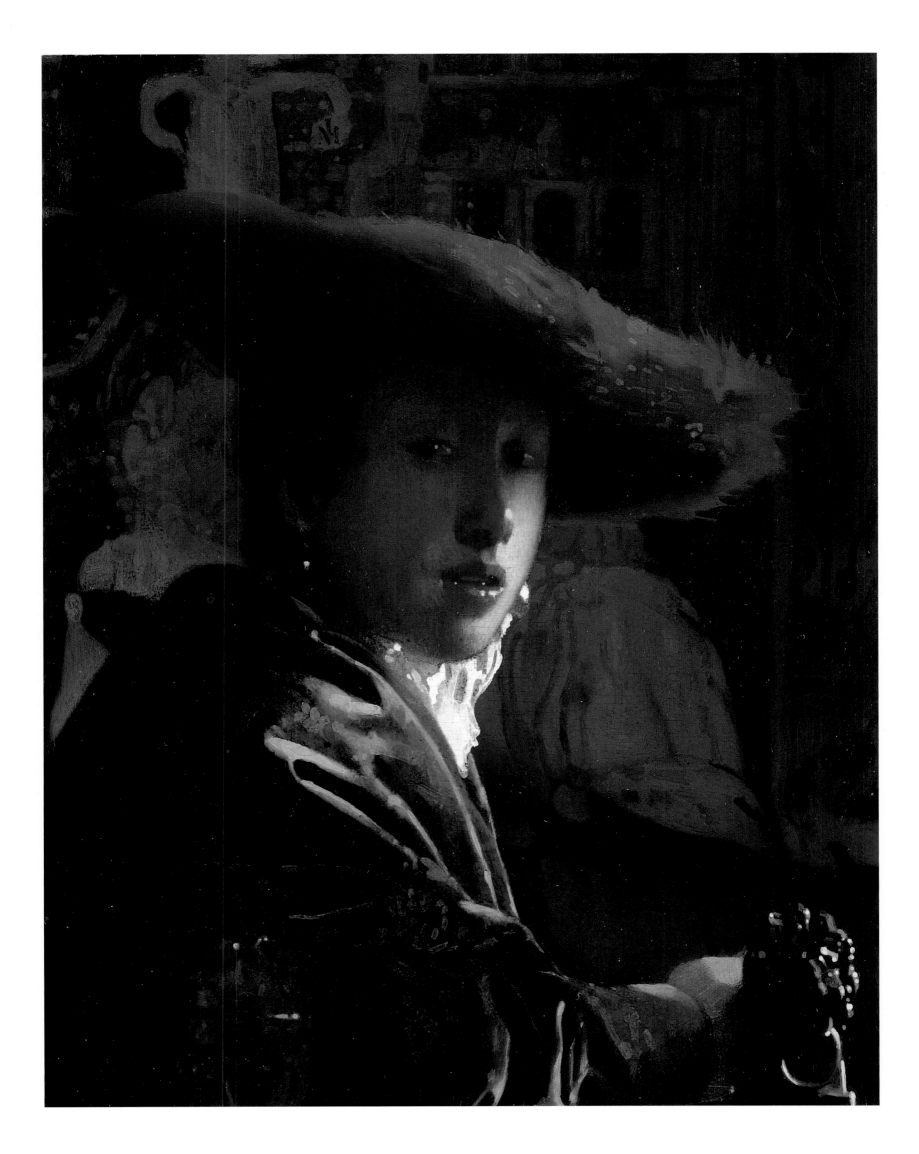

Plate 24

THE ART OF PAINTING

c. 1666—1667. Oil on canvas, 47 ¼ x 39 ⅜″ (120 x 100 cm).
Kunsthistorisches Museum, Vienna

Throughout much of his career Vermeer drew inspiration from his observations of daily life, but he remained at his core a history painter, one who sought to evoke abstract meanings in his works. He used color, light, perspective, and objects—including pearls, paintings, and maps—to help express the fundamental spiritual and human emotions he wished to instill in his paintings. While most of his scenes look real, in two instances, *The Art of Painting* and *Allegory of Faith* (Pl. 33), allegory takes precedence.

In *The Art of Painting* Vermeer sought to indicate how the artist, through his awareness of history and his ability to paint elevated subjects, brings fame to his native city and country. Vermeer announces his allegorical intent with a large curtain, drawn back as though revealing a *tableau vivant* of an artist painting a young model. Her attributes—a laurel wreath symbolizing honor and glory, a large book signifying history, and the trumpet of fame—identify her as Clio, the muse of history. Other objects in the elaborate interior reinforce Vermeer's underlying concept. The large map of the Netherlands with its flanking city views was outdated when Vermeer depicted it, its age apparent from the vertical creases crossing its middle. Similarly, the chandelier, which is surmounted by a double-headed eagle, the imperial symbol of the Hapsburgs, refers to an earlier era when that dynasty ruled the country.

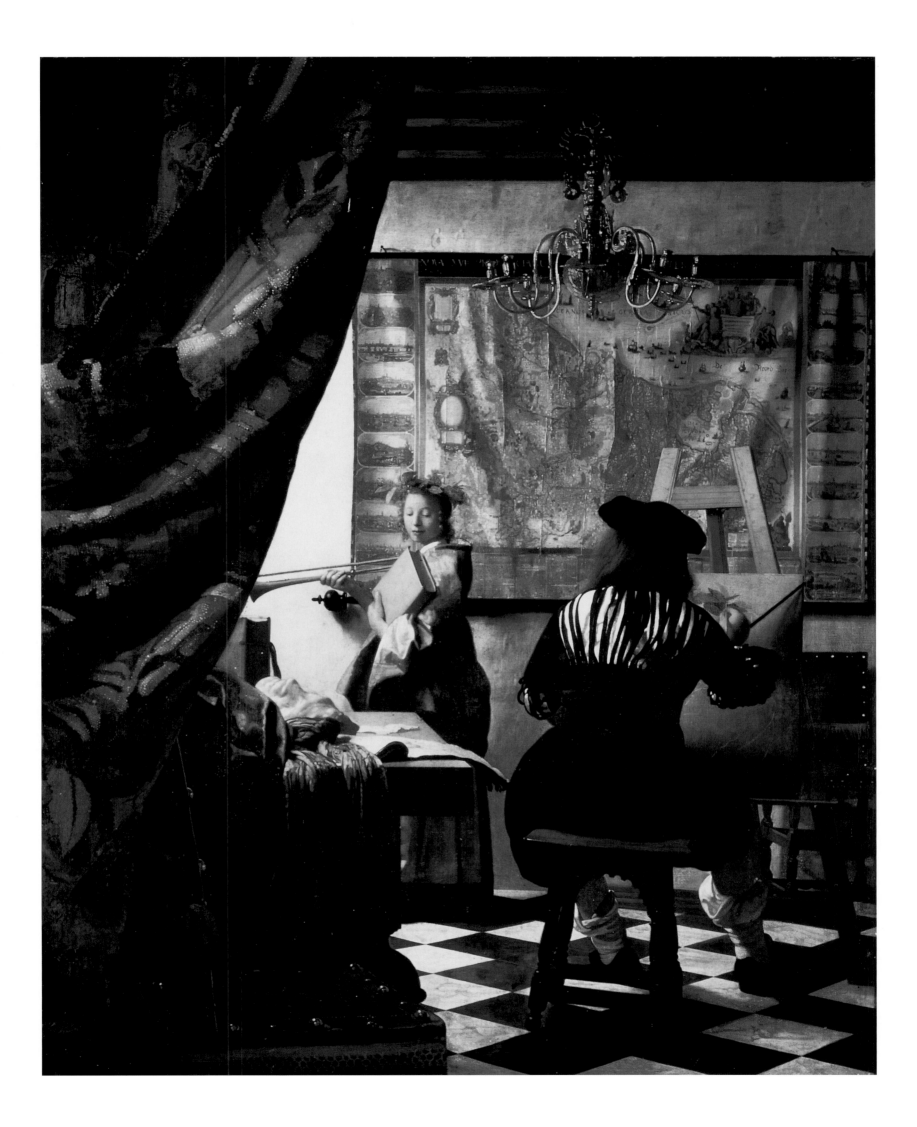

Plate 25

MISTRESS AND MAID

c. 1667—1668. Oil on canvas, 35 ½ x 31" (90.2 x 78.7 cm).
The Frick Collection, New York

Throughout the late 1650s and early-to-mid 1660s, Vermeer's paintings depict figures that convey a sense of inner harmony as they go about their lives in the privacy of their well-ordered interiors. However, with this work, Vermeer used the love letter theme as a means to explore the anxieties that inevitably arise in human relationships. In doing so, he also introduced a new compositional device, the sudden interruption of a figure's private thoughts by another individual.

The mistress, who sits at her writing table with pen in hand, responds to the unexpected arrival of the letter by involuntarily bringing her hand to her chin. Instead of reaching out with joy and expectation, she, with measured gesture and reflective expression, quietly ponders its implications. The maid looks at the mistress with a caring expression, as though she appreciates the significance of the event. Vermeer neither explains the circumstances for this poignant moment of doubt and apprehension nor indicates its outcome, focusing instead on the emotional interchange unfolding before us.

Vermeer enhanced the character of the mistress's emotional reaction through his suggestive painting technique. He purposely softened her features by subtly modulating her flesh tones. For example, he hardly defined her eye, which, nevertheless, poses questions as it intently stares at the letter.

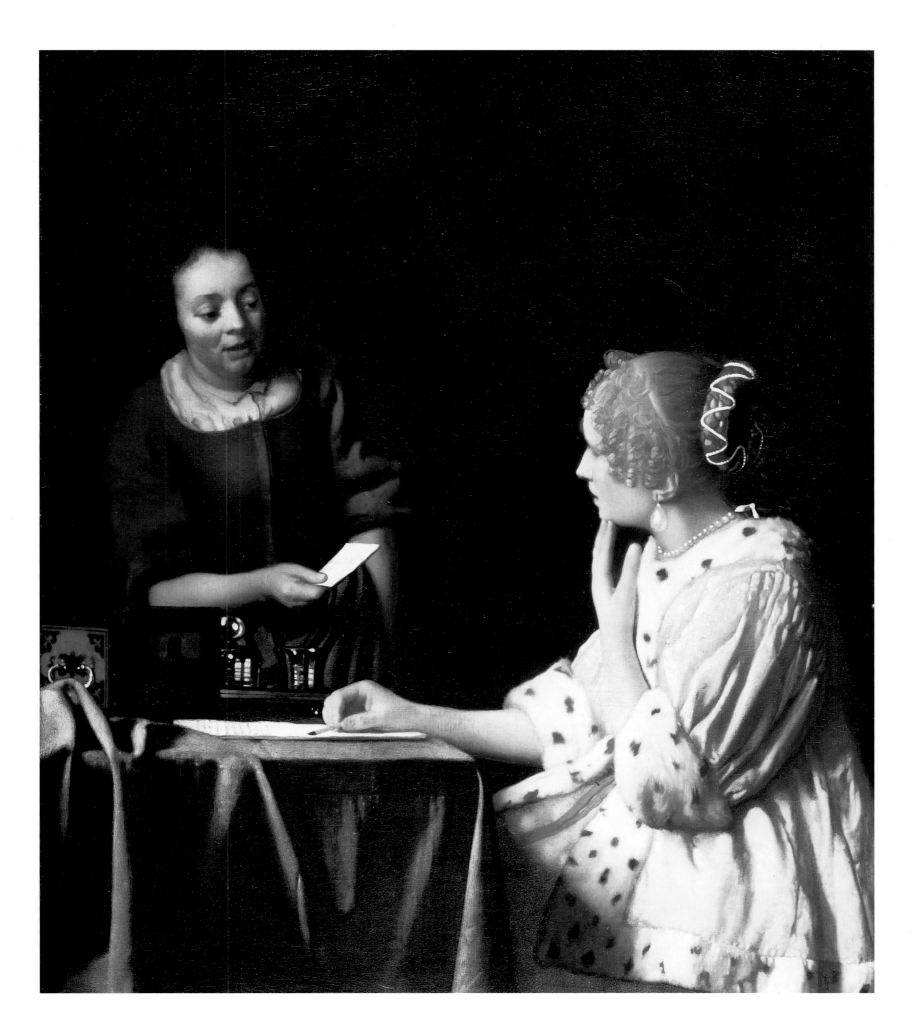

Plate 26

PORTRAIT OF A YOUNG WOMAN

c. 1667–1668. Oil on canvas, 17 ½ x 15 ¾" (44.5 x 40 cm).
The Metropolitan Museum of Art, New York. Gift of Mr. and Mrs.
Charles Wrightsman, in memory of Theodore Rousseau, 1979

In painting this portrait, Vermeer adapted the pose he had used in
Girl with a Pearl Earring (Pl. 21), even to the extent of draping her
hair with a yellow cloth that similarly falls behind her shoulder. In
this instance, however, he emphasized the smoothness and purity of
her skin by contrasting it with a freely brushed, loosely fitting robe.

Plate 27 (overleaf)

THE GEOGRAPHER

c. 1668–1669. Oil on canvas, 20 ⅞ x 18 ¼" (53 x 46.6 cm).
Städelsches Kunstinstitut, Frankfurt-am-Main, Germany

Plate 28 (overleaf)

THE ASTRONOMER

1668. Oil on canvas, 19 ⅝ x 17 ¾" (50 x 45 cm).
Musée du Louvre, Paris

The many compositional and thematic relationships between *The
Geographer* and *The Astronomer* indicate that Vermeer conceived
these works as pendants. One senses in the scholars' purposeful
expressions as they lean forward, with one hand firmly grasping a
solid support, the excitement of intellectual inquiry as their inquisi-
tive minds actively search for answers to questions they have posed
about the earth and the stars.

The inquiries of the geographer—the study of the earth—and
the astronomer—the study of the stars and planets—concerned
two closely allied scientific realms, both of which were of great
practical use in navigation, a concern important to the Dutch.
Vermeer emphasized the interrelatedness of the paintings by depict-
ing terrestrial and celestial globes that the mapmaker Jodocus
Hondius published as a pair in 1618.

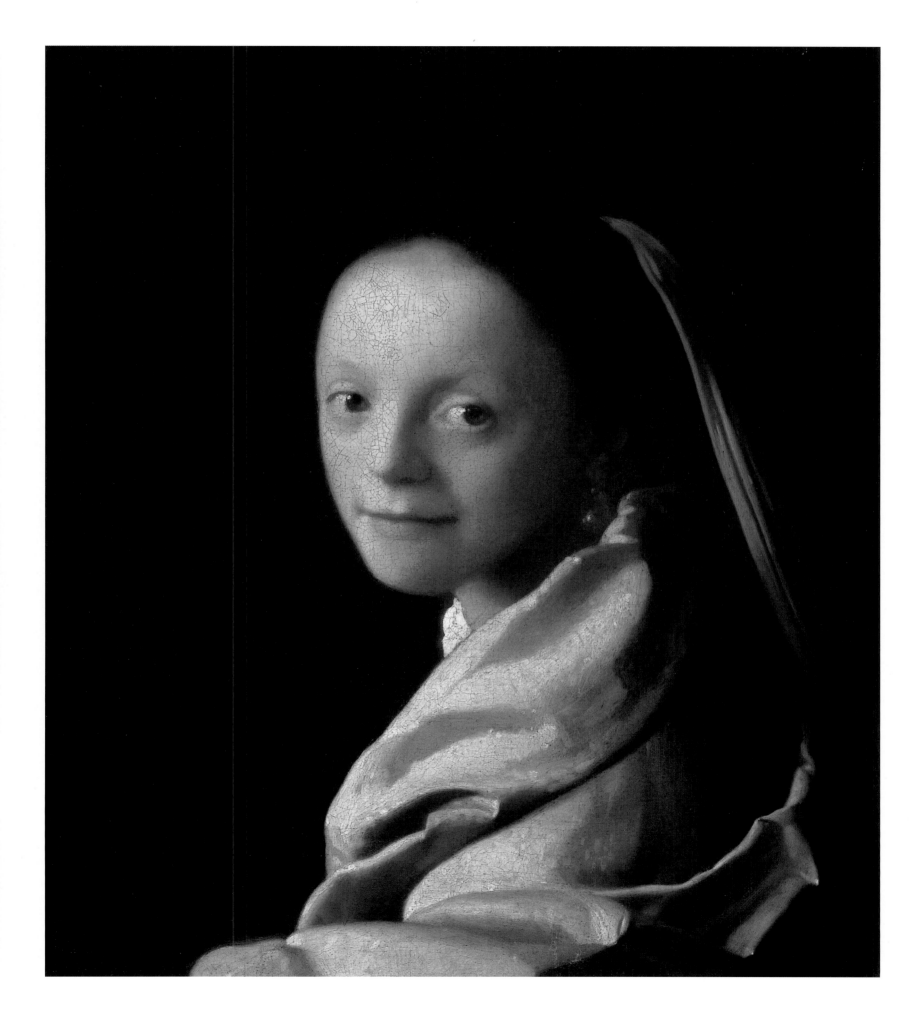

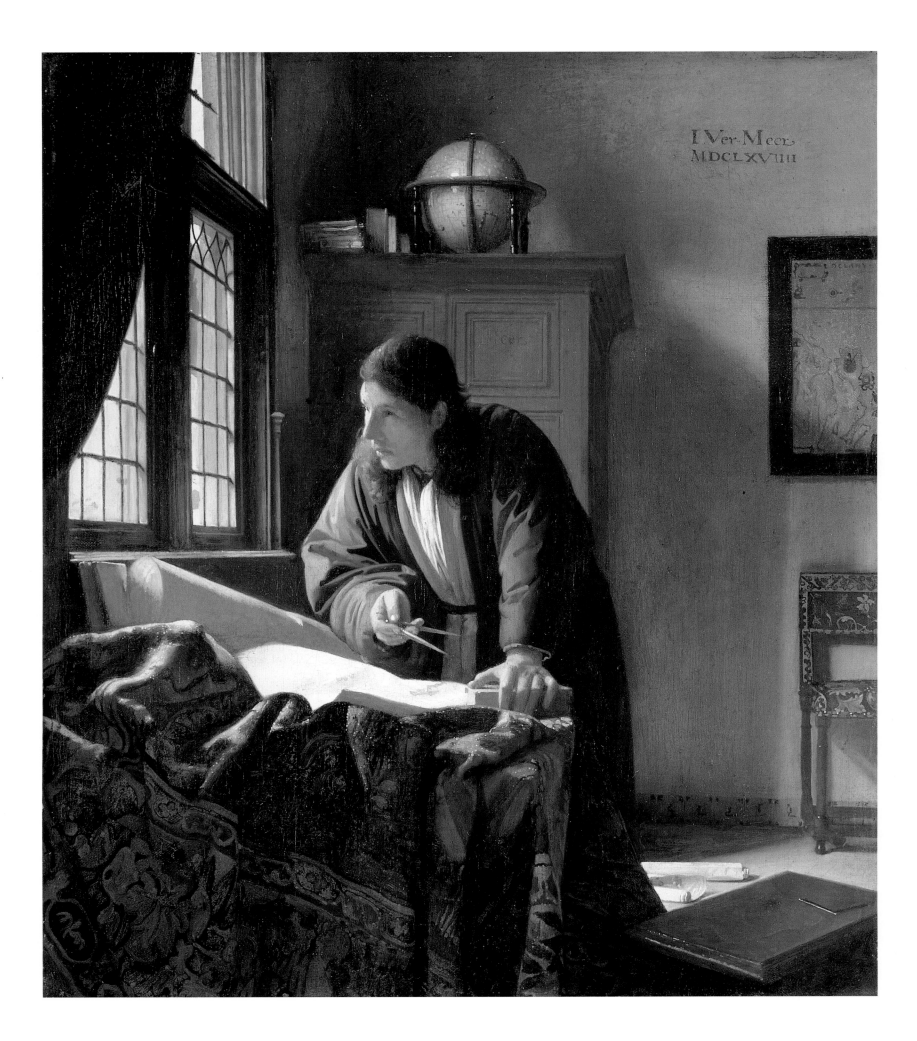

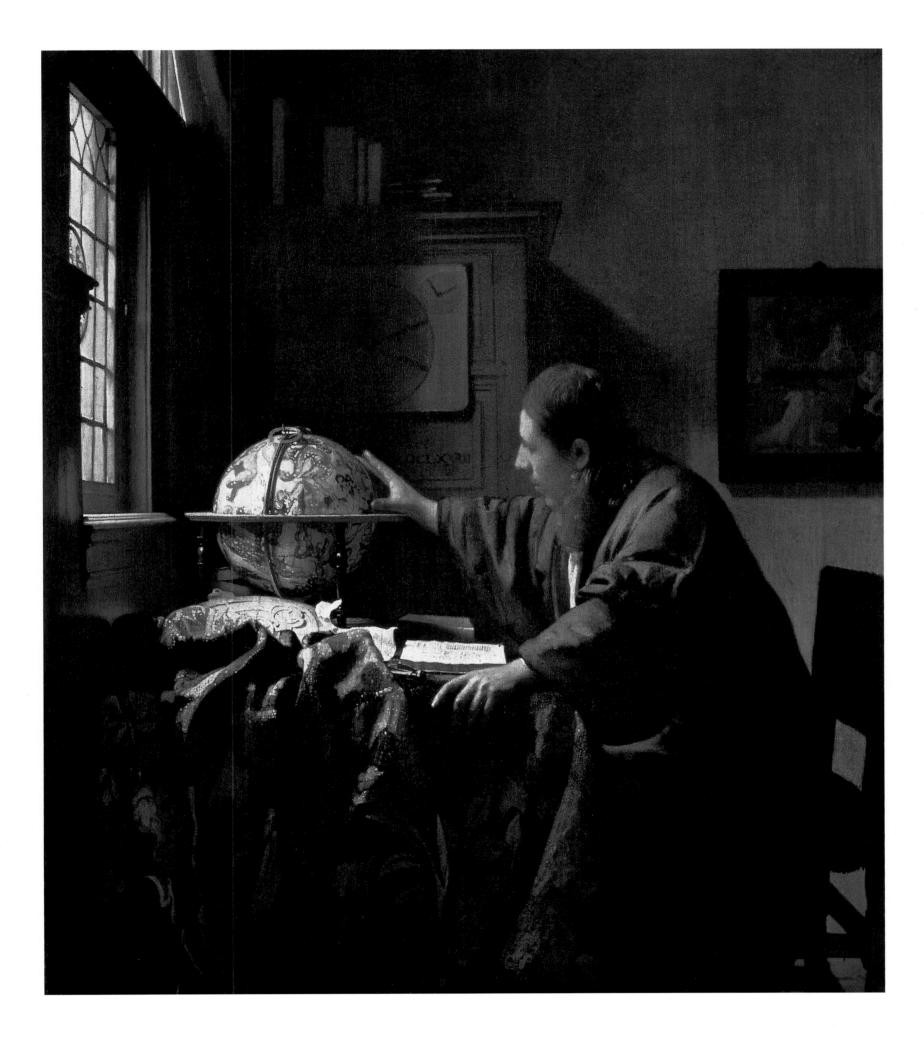

Plate 29

THE LACEMAKER

c. 1669–1670. Oil on canvas (attached to panel), 9 ⅝ x 8 ¼"
(24.5 x 21 cm). Musée du Louvre, Paris

Vermeer brings the viewer right into this small, intimate scene,
where one can instantaneously feel the young woman's absorption
in her craft as she bends over her lacemaking cushion. With infinite
patience, she skillfully knots the lace while holding two bobbins in
one hand. Vermeer emphasized the intensity of her concentration
by contrasting the tautness of the silk strands she holds with the
fluid red and white threads flowing from the blue cushion on the
table before her.

Much as with the finials in *Girl with the Red Hat* (Pl. 23),
Vermeer painted these threads in a remarkably free and expressive
manner. Indeed, their diffused forms assume characteristics of the
"circles of confusion" seen in an unfocused image in a camera
obscura. Although Vermeer would not have traced over a camera
obscura image in this, or any of his other paintings, he carefully
observed optical effects that occur in such a device, re-creating in
paint those that he particularly admired for their expressive quali-
ties. Unfocused highlights also helped establish depth of field.
Here, for example, the diffused threads encourage the viewer to
look beyond the immediate foreground to the more sharply focused
face and hands.

The Dutch considered lacemaking a domestic virtue, for it
required great discipline and industriousness. Perhaps for this rea-
son Vermeer placed a small, parchment-covered book, presumably
a prayer book, behind the blue cushion.

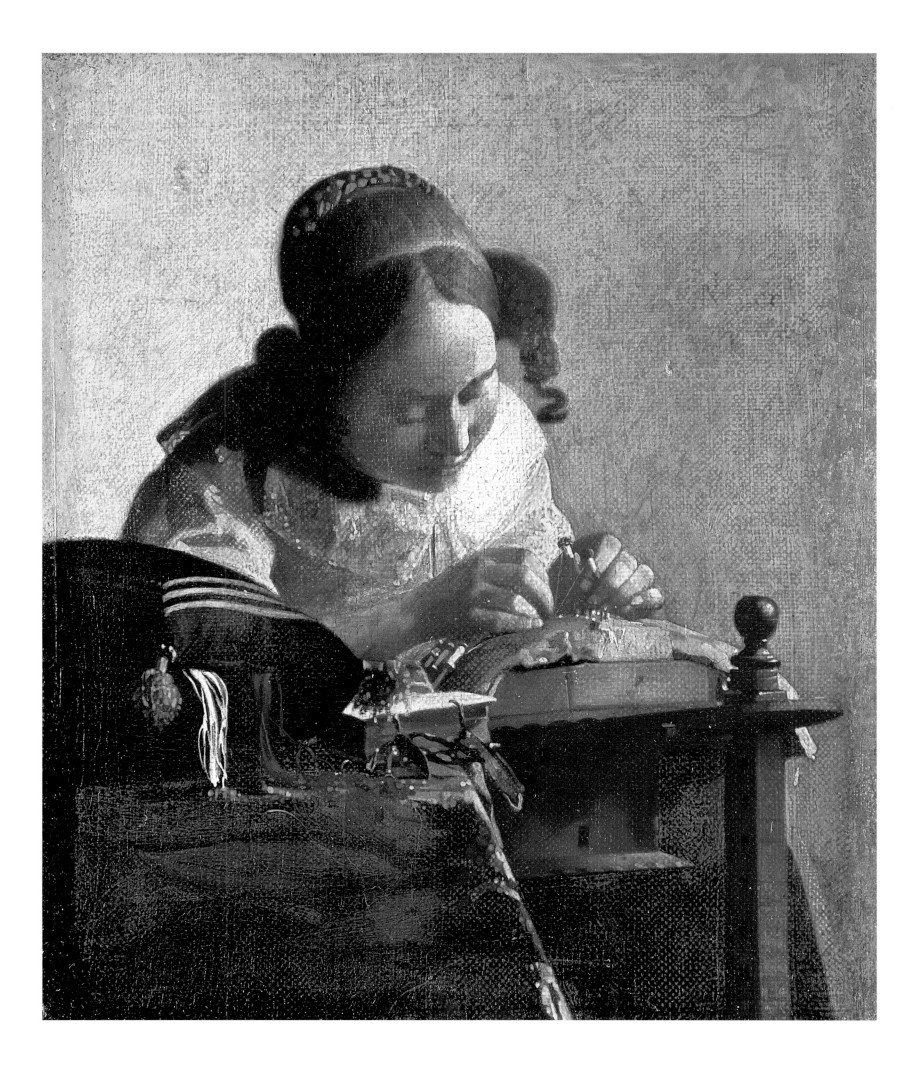

Plate 30

THE GUITAR PLAYER

*c. 1670. Oil on canvas, 20 7/8 x 18 1/4" (53 x 46.3 cm). Kenwood,
English Heritage as Trustees of The Iveagh Bequest, London*

This painting exudes a joyous energy that makes it one of Vermeer's
most appealing works. One can almost hear the chords of the music
the woman plays, an effect Vermeer created by painting diffused
guitar strings that seemingly vibrate from her touch. Indeed, the
image's spontaneity results largely from the vigor of Vermeer's
increasingly abstract manner of painting, as in the boldly unmodu-
lated planes of color defining her dress.

Plate 31 (overleaf)

THE LOVE LETTER

*c. 1669–1670. Oil on canvas, 17 3/8 x 15 1/8" (44 x 38.5 cm).
Rijksmuseum, Amsterdam*

In this dramatic work the viewer peers through a doorway to a well-
appointed room, where the mistress turns from her cittern and
looks questioningly at the maid after being handed a letter. Unlike
the thematically related *Mistress and Maid* (Pl. 25), where Vermeer
does not reveal the consequences of the unexpected epistle, the
maid's reassuring smile and the calm seas in the painting behind her
signify a positive outcome.

Plate 32 (overleaf)

LADY WRITING A LETTER WITH HER MAID

*c. 1670. Oil on canvas, 28 x 23" (71.1 x 58.4 cm).
National Gallery of Ireland, Dublin*

Partly through their varied poses, Vermeer created strikingly differ-
ent emotional states for the mistress, as she intently writes a letter,
and the maid, as she calmly awaits it. He reinforced this distinction
with the strong light striking the mistress, and the abstract, angular
folds on her sleeve.

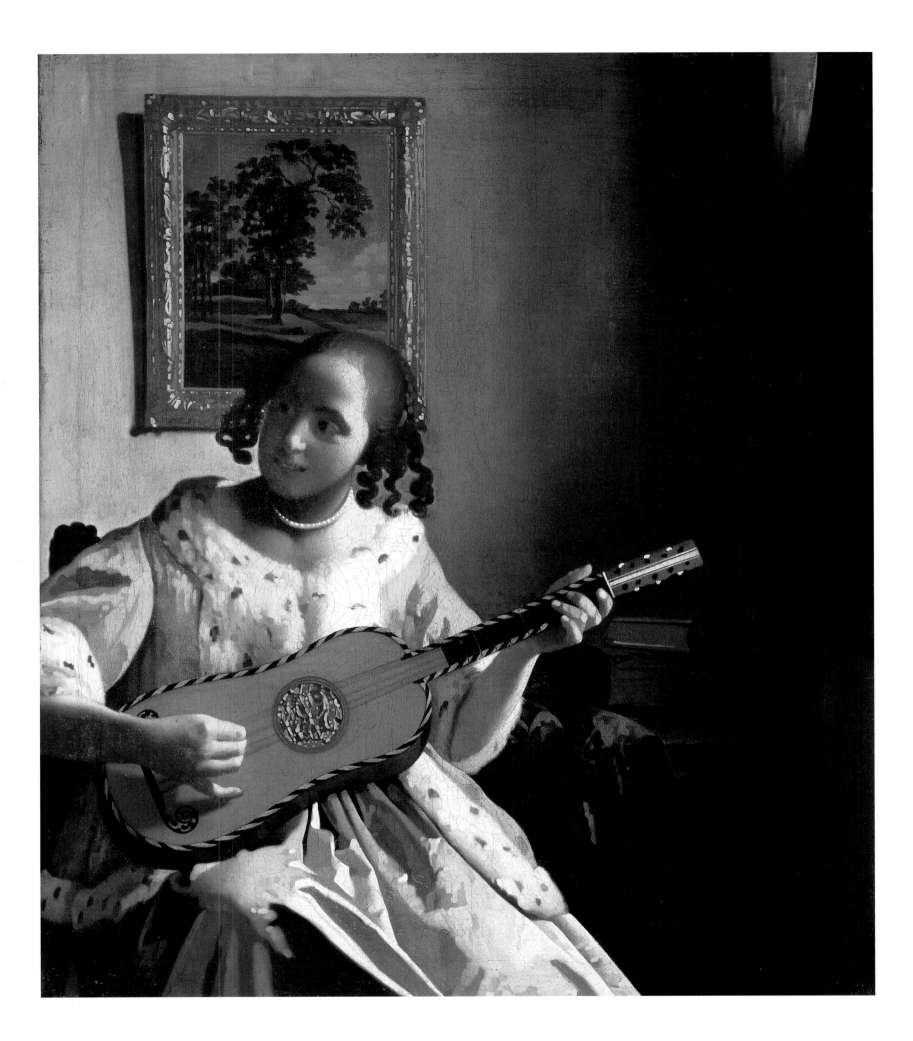

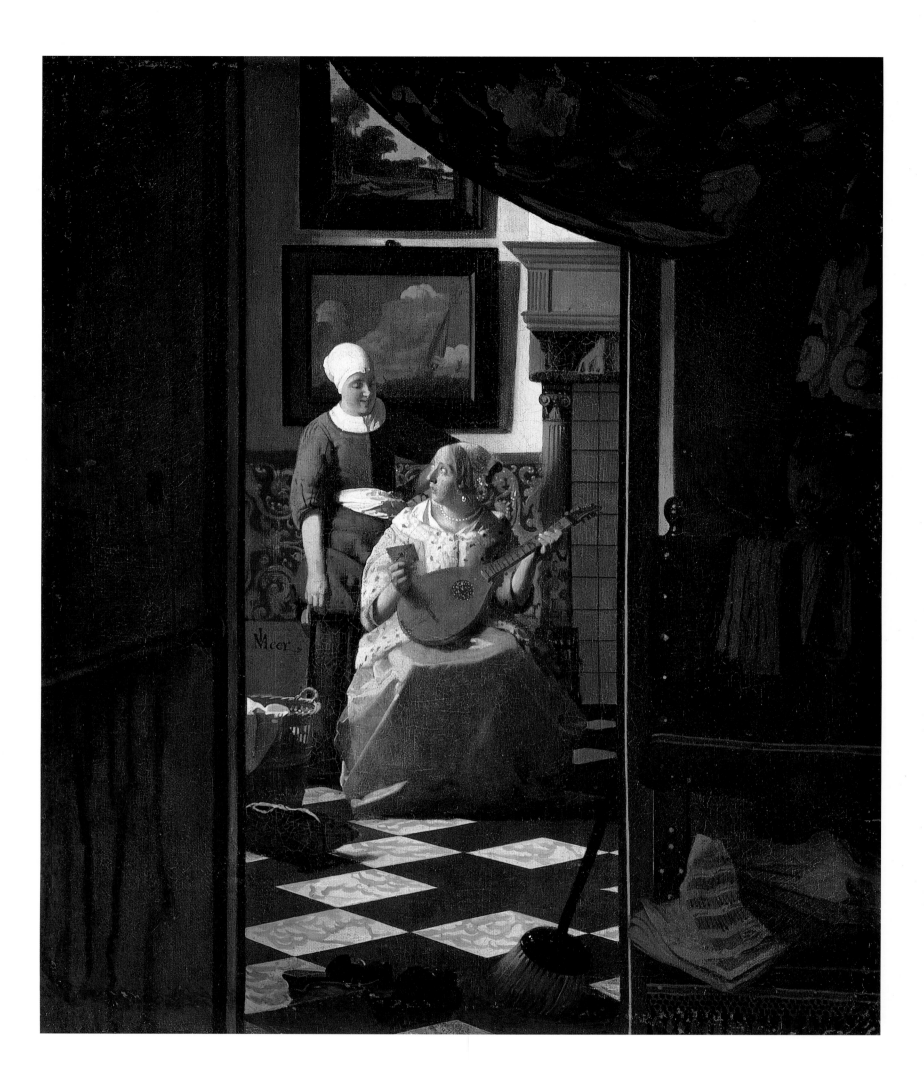

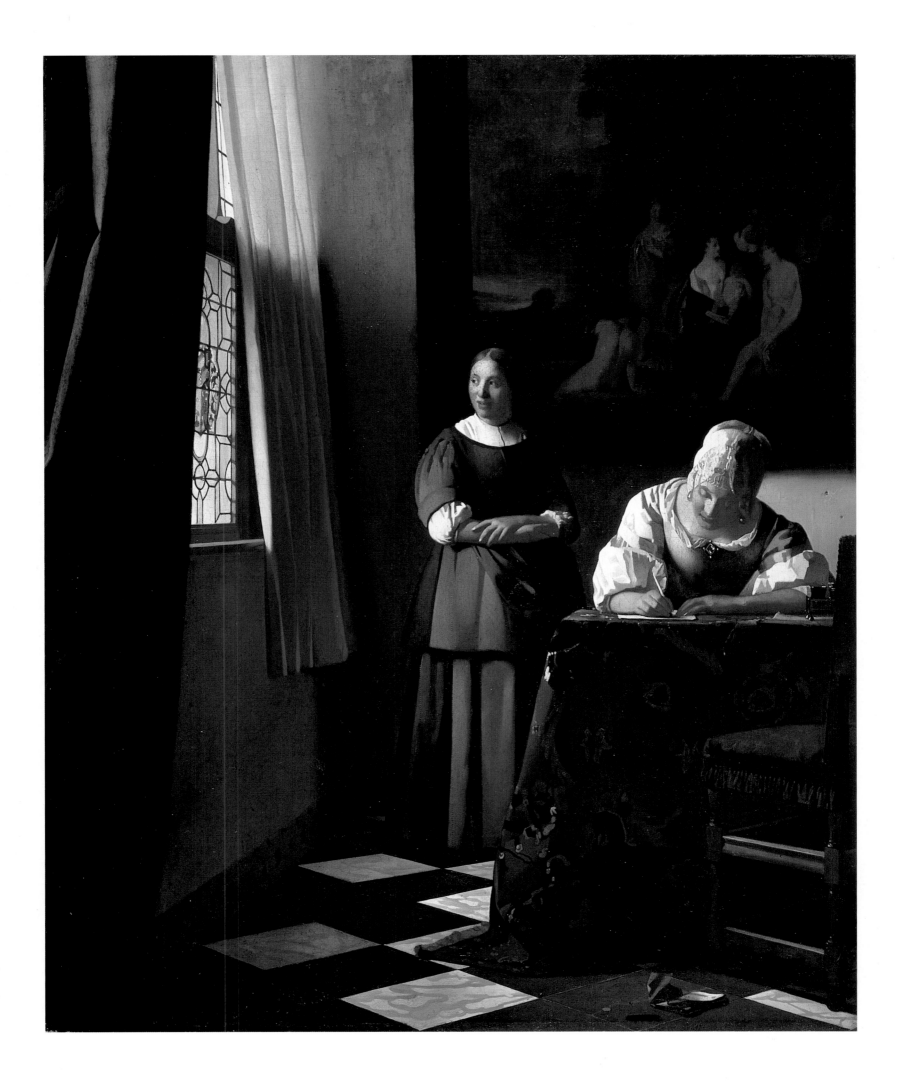

Plate 33

ALLEGORY OF FAITH

c. 1671–1674. Oil on canvas, 45 x 35" (114.3 x 88.9 cm).
The Metropolitan Museum of Art, New York. Bequest of Michael
Friedsman, 1931. The Friedsman Collection

In painting *Allegory of Faith,* Vermeer returned to the composi-
tional format he so successfully devised for *The Art of Painting*
(Pl. 24). Nevertheless, a profound difference exists between the
two. Whereas the earlier painting functions as both a realistic por-
trayal of an artist in his studio and as an allegory, the scene unfold-
ing beyond this curtain can only be understood in allegorical terms.
Indeed, a number of iconographic elements integral to the meaning
of the allegory seem out of place within this carefully constructed
Dutch interior, among them: the snake crushed by a large corner-
stone, which represents Christ overcoming evil; the woman's gesture
of bringing one hand to her breast to indicate her true faith; and
the glass ball suspended from the ceiling, an object that symbolizes
man's capacity to believe in God.

Vermeer's reasons for painting this allegory are not known. He
may have executed it for the Jesuit Order in Delft or for a wealthy
Catholic patron. He derived many of the theological concepts from
descriptions of the allegorical figure of Faith in the 1644 Dutch
edition of Cesare Ripa's *Iconologia,* a book particularly admired by
the Jesuits. Vermeer, however, amplified Ripa's comments by includ-
ing objects from his own household, for example, the ebony crucifix
and the gilt leather panel. Also listed in the inventory of his collec-
tion was a painting of the *Crucifixion,* which must be the work by
Jacob Jordaens he has depicted hanging on the rear wall.

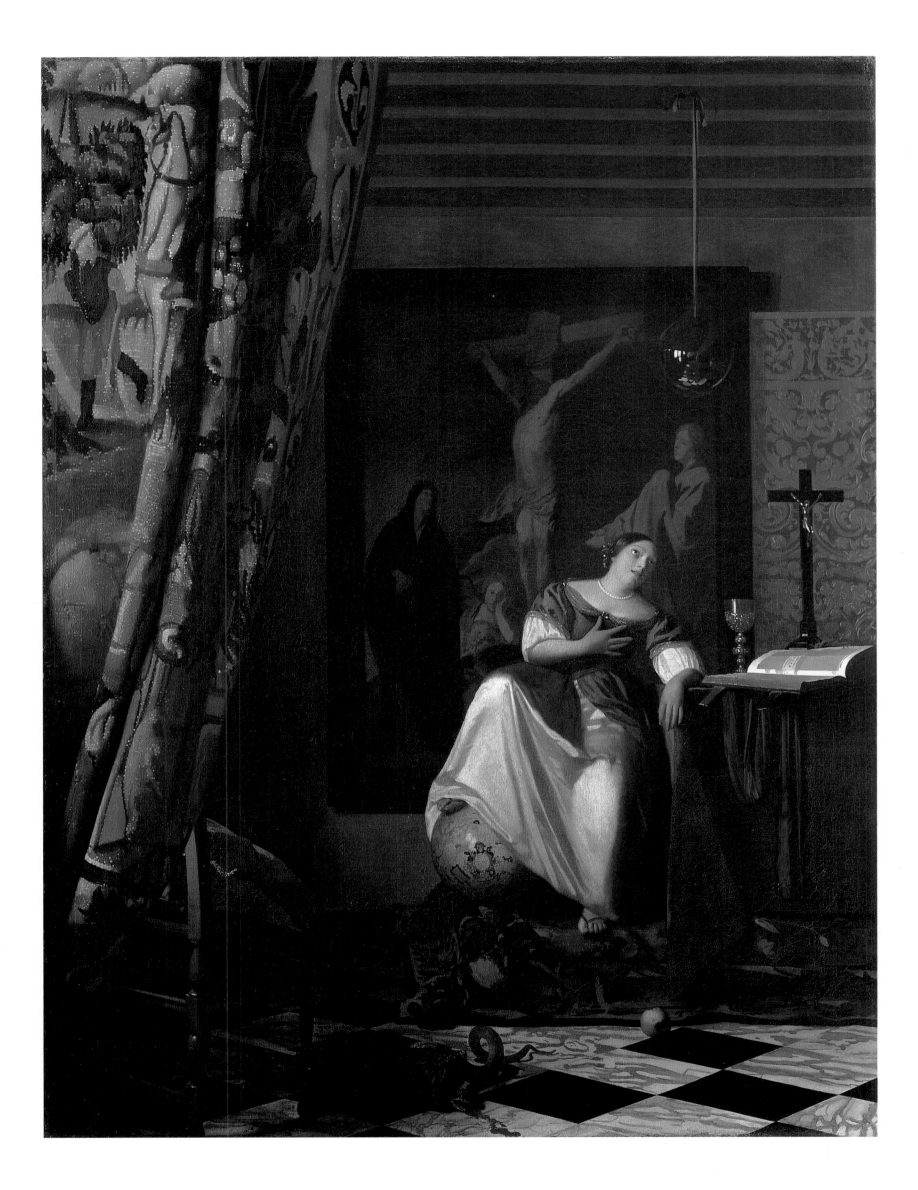

Plate 34

A LADY STANDING AT THE VIRGINAL

c. 1672–1673. Oil on canvas, 20 ⅜ x 17 ¾" (51.7 x 45.2 cm).
Reproduced by Courtesy of the Trustees, National Gallery, London

Vermeer's genre scenes of the 1670s have a crystalline clarity quite unlike the softly modulated images of the 1660s. These paintings have a stark simplicity of composition, where the relationships between figures and their surroundings are distinctly defined. In these works Vermeer no longer sought to create the illusion of reality with textural effects. Rather, he subtly abstracted his forms by modeling them with carefully nuanced planes of light, shade, and color. For example, these stylistic tendencies are evident in *A Lady Standing at the Virginal* in the defined wall patterns around the virginal and the paintings hanging behind the woman. They are also evident in the abstract shapes the artist used to indicate the broken texture of the elaborate gold picture frame, and in the broad planes with which he defined the flat, black surface of the ebony one.

Although the thematic framework for Vermeer's late genre paintings remained rooted in scenes drawn from everyday life, his narrative approach is also more direct, and his admonitory tone less psychologically nuanced. Here, the woman has turned away from the virginal and stares purposefully out at the viewer. The musical instrument she plays had a traditional association with the purity of love. This same sentiment is reinforced by the image of Cupid holding aloft a card, which is based on a well-known emblem from Otto van Veen's *Amorum Emblemata*, 1608, that states a "lover ought to love only one" (Fig. 22).

Fig. 22. Otto van Veen, "Only One." Illustration from Amorum Emblemata, *published Antwerp, 1608. Engraving, 5 x 5 ½"
(13 x 14 cm). National Gallery of Art Library, Washington, D.C.*

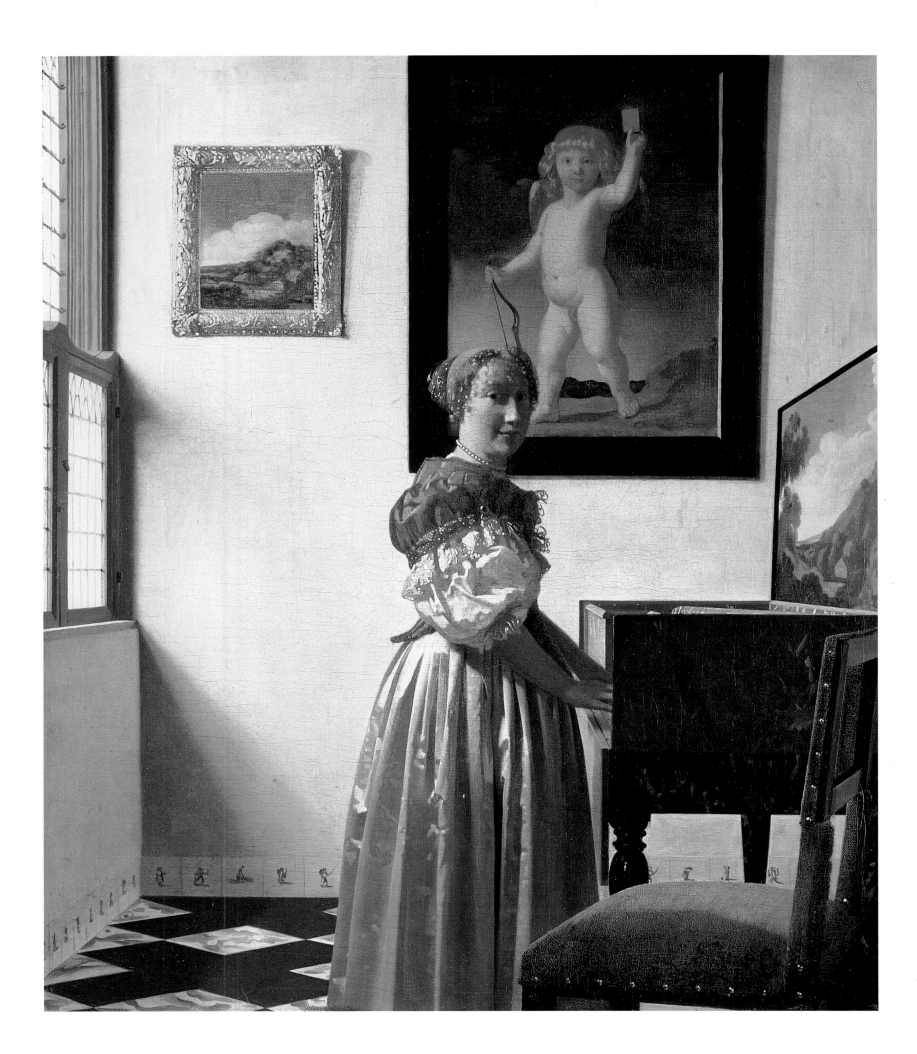

Plate 35

A LADY SEATED AT THE VIRGINAL

c. 1675. Oil on canvas, 20 ¼ x 17 ⅞″ (51.5 x 45.5 cm).
Reproduced by Courtesy of the Trustees, National Gallery, London

This painting shares many compositional and thematic elements
with *A Lady Standing at the Virginal* (Pl. 34), but it seems unlikely
that Vermeer painted the two works as pendants. An inventory
made shortly after Vermeer's death indicates that one of these
works, but not both, was owned by Diego Duarte, an organist and
composer who lived in Antwerp. Duarte's painting was one of the
very few works by Vermeer owned by a non-Delft collector prior to
1696, when twenty-one of his paintings were sold in Amsterdam as
part of the Jacob Dissius collection. Another argument against their
being pendants is that the two paintings differ stylistically. The
modeling of folds on the woman's blue dress in this picture is more
abstract than is seen in *A Lady Standing at the Virginal,* which sug-
gests that Vermeer executed this one at a later date.

On the rear wall hangs Dirck van Baburen's *The Procuress* (see
Fig. 6), which Vermeer also included in *The Concert* (Pl. 22),
although he has here adjusted its size and proportion. He also
placed a gold frame around it rather than a black one. Vermeer
intended this scene of illicit love to contrast thematically with the
bass viol lying next to the virginal. This unattended instrument
alludes to an emblem by Jacob Cats indicating the joy of two hearts
joined in harmonious love (see Fig. 19). His juxtaposition of these
two thematic elements, thus, relates to the choice between profane
and ideal love. Vermeer reveals the path he recommends through
the strong sunlight illuminating the bass viol.

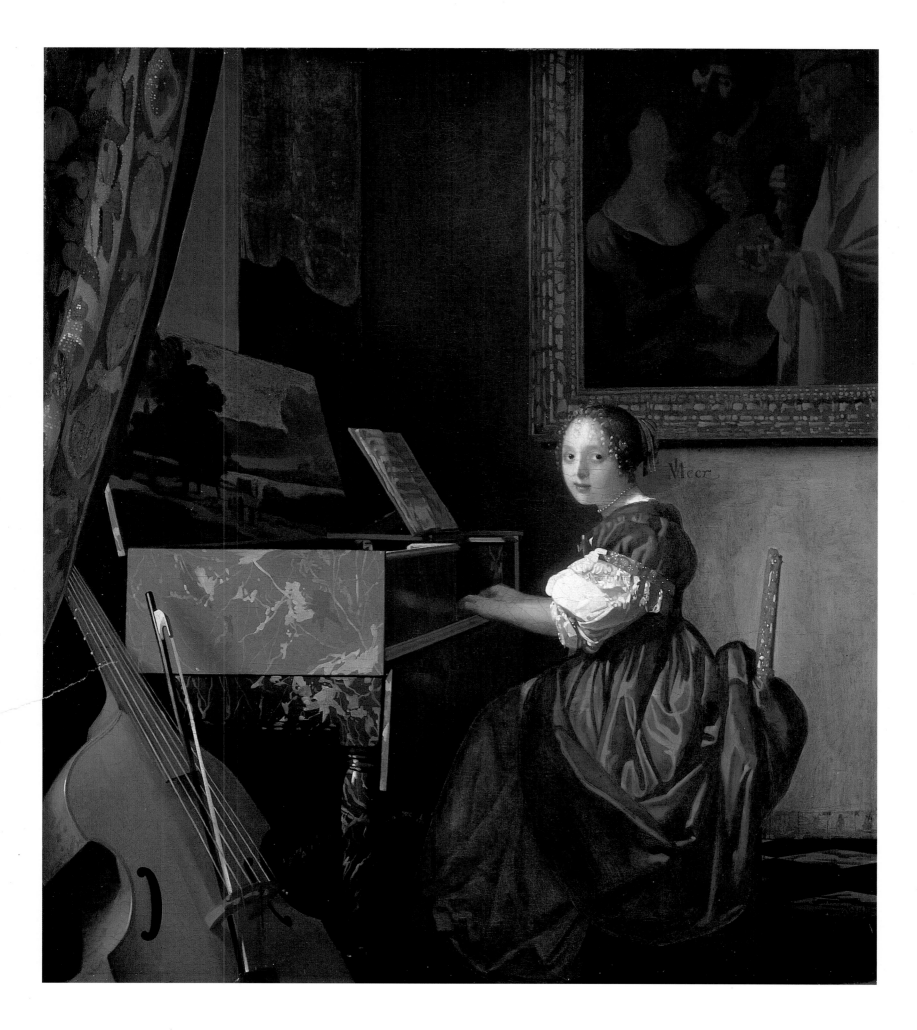

Editor: Elaine M. Stainton
Designer: Robert McKee
Photo Editor: Uta Hoffmann

Library of Congress Cataloging-in-Publication Data
Wheelock, Arthur K.
 Vermeer: the complete works / Arthur K. Wheelock, Jr.
 p., cm.
 ISBN 0–8109–2751–9 (pbk.)
 I. Vermeer, Johannes, 1632–1675. 2. Painters—
Netherlands—Biography. 3. Vermeer, Johannes,
1632–1675—Themes, motives.
 I. Vermeer, Johannes, 1632–1675. II. Title.
ND653.V5W49 1997
759.9492—dc21
[B] 97–399

Harry N. Abrams, Inc.
100 Fifth Avenue
New York, N. Y. 10011
www.abramsbooks.com